THIS BOOK
IS FOR YOU

(I HOPE YOU FIND IT MILDLY UPLIFTING)

BY WORRY LINES

TEN SPEED PRESS
CALIFORNIA | NEW YORK

CONTENTS

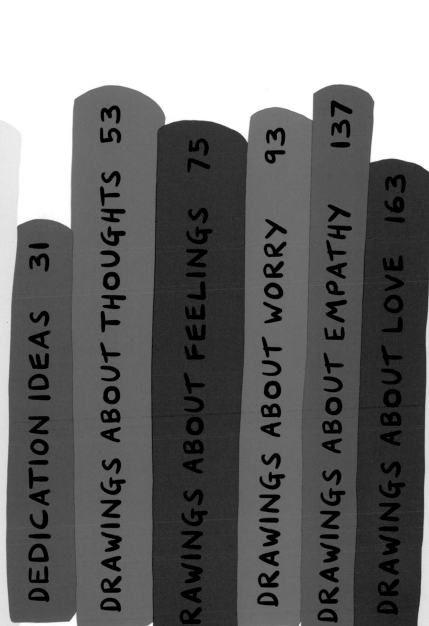

THIS IS ME

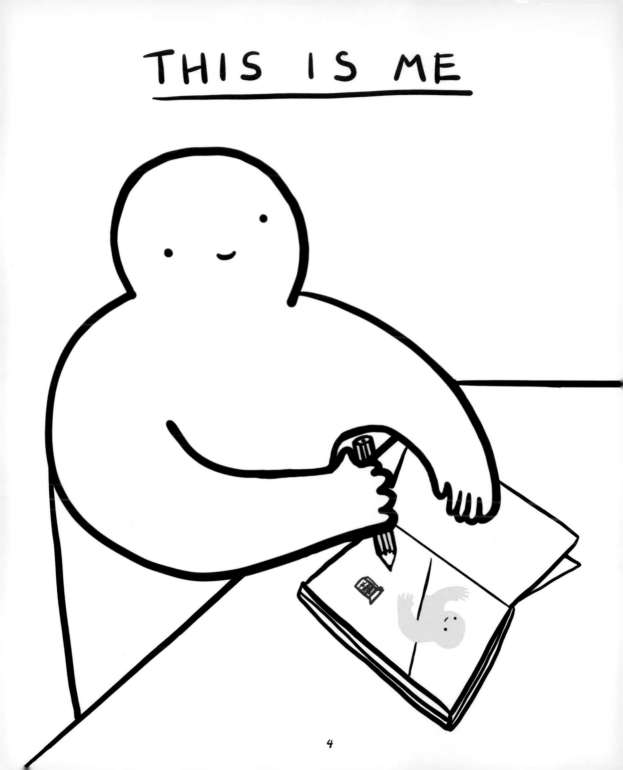

THIS IS HOPE

THIS IS WORRY

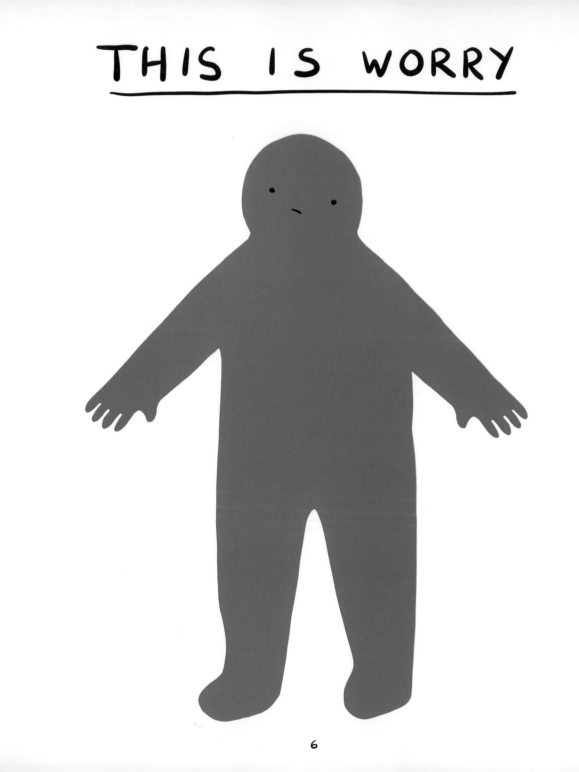

THIS BOOK IS
FOR YOU

A NOTE FROM THE AUTHOR

WHEN THE GOOD PEOPLE AT TEN SPEED PRESS AGREED TO
PUBLISH THIS BOOK - A COLLECTION OF MY MOST POPULAR
DRAWINGS ABOUT THOUGHTS, FEELINGS, WORRY, AND EMPATHY
FRAMED BY A HOPEFUL NARRATIVE - I WAS THRILLED.
I'D ALWAYS WANTED TO MAKE A LONG-FORM PROJECT AND THIS
SEEMED LIKE THE PERFECT OPPORTUNITY TO MAKE SOMETHING
THAT COULDN'T EXIST ON THE INTERNET - SOMETHING THAT
ONLY MADE SENSE AS A BOOK. I WAS EXCITED TO GET
DRAWING.

BUT ALMOST BEFORE I HAD TIME TO REGISTER THE EXCITEMENT,
I WAS OVERCOME BY ANOTHER FAMILIAR EMOTION: WORRY.

I'VE LIVED WITH WORRY MY WHOLE LIFE. IT HAS BEEN BOTH A
CONSTANT COMPANION AND A SOURCE OF COMPLETE CREATIVE
PARALYSIS. I KNEW THAT IF I ALLOWED MYSELF TO WORRY NOW,
ABOUT THIS BOOK, THEN THIS BOOK WOULD NOT GET MADE.
I KNEW THAT IF I LET IT, WORRY WOULD SOON DOMINATE THE
WHOLE PROJECT AND I COULD RUN THE RISK OF JEOPARDIZING
NOT ONLY THE BOOK, BUT MY OWN MENTAL HEALTH AS WELL.

AND SO I DECIDED, FOR THE FIRST TIME IN MY LIFE, THAT I WAS

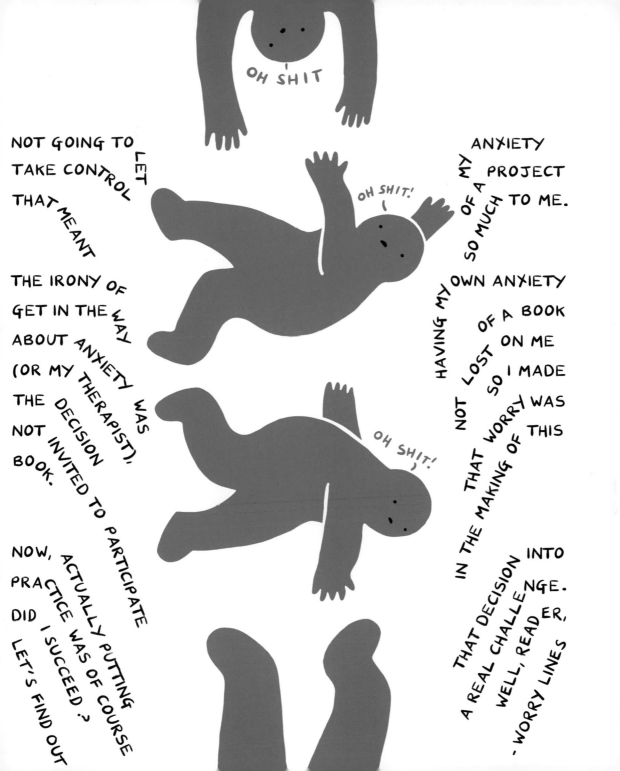

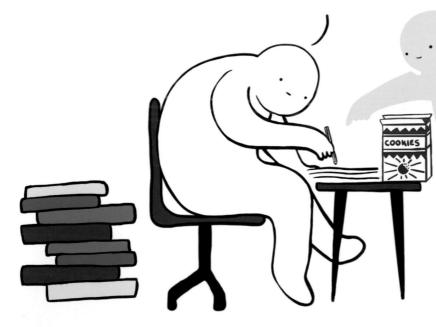

INCOMING!

11

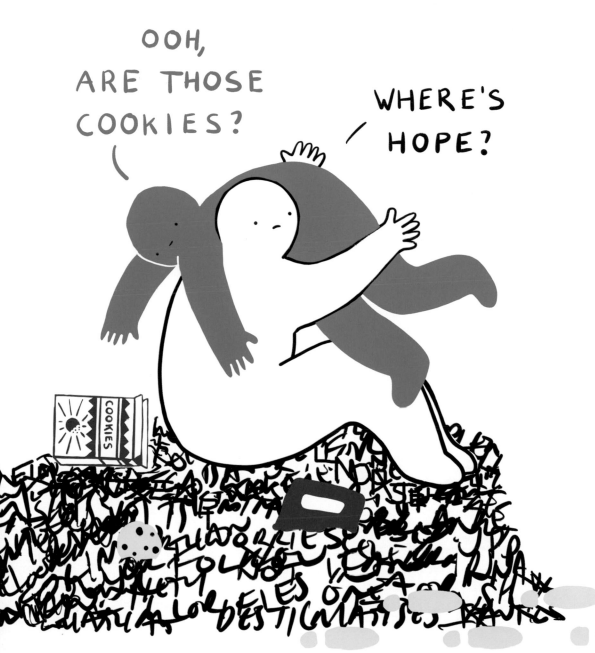

15

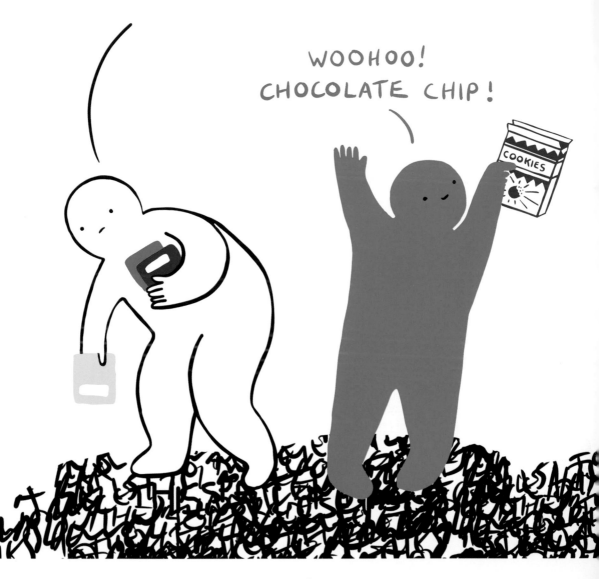

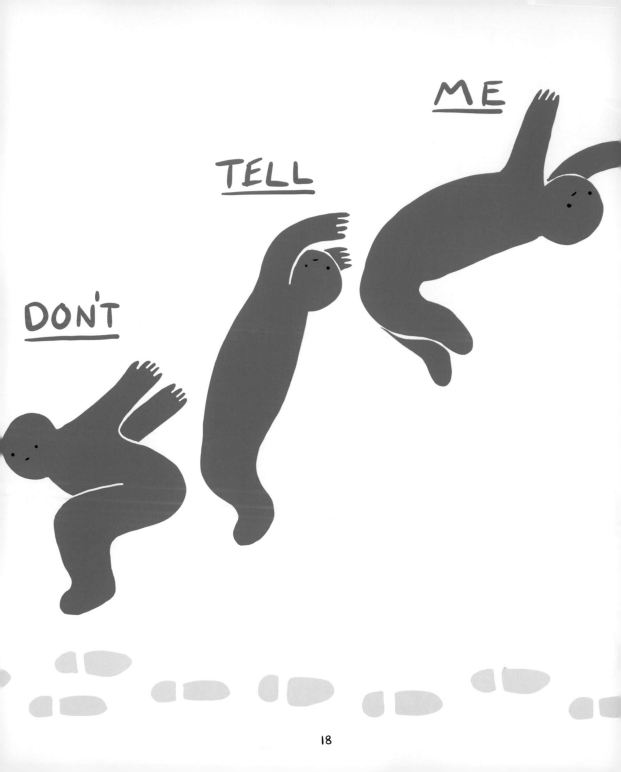

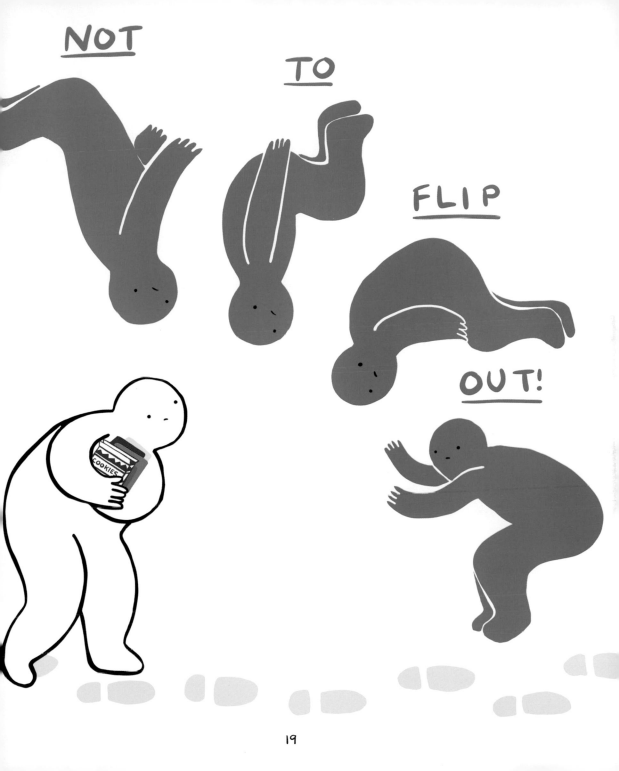

19

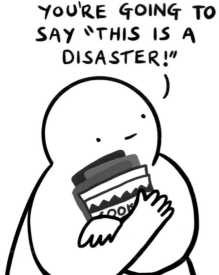

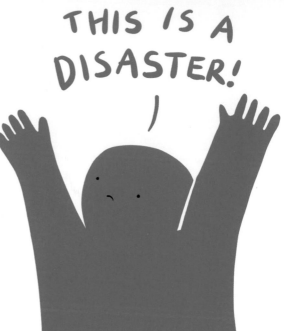

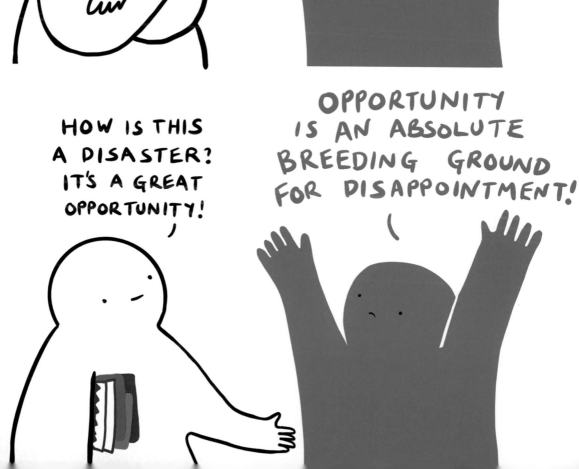

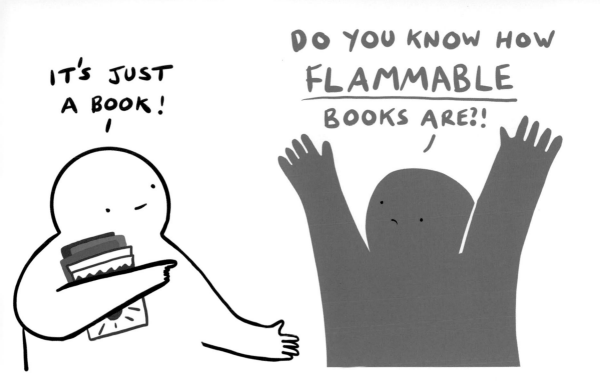

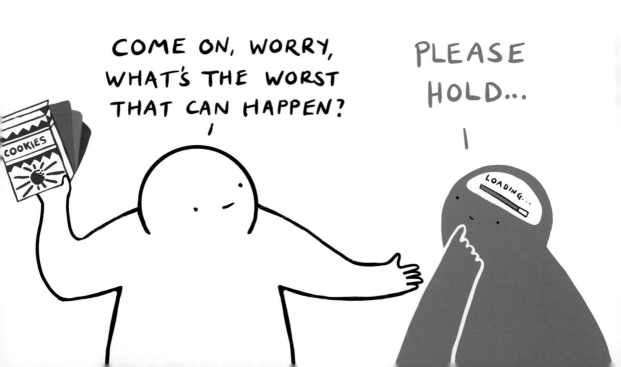

PUBLIC
HUMILIATION?

HAVING TO
MAKE SMALL
TALK WITH A
TAXI DRIVER?

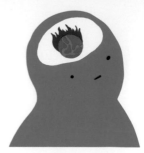

COMPLETE
ECOLOGICAL
COLLAPSE?

GETTING STUCK
IN AN ELEVATOR
WITH YOUR
THERAPIST?

REALIZING
YOU AREN'T
WHO YOU
THOUGHT YOU
WERE?

GETTING STUCK
IN AN ELEVATOR
WITHOUT YOUR
THERAPIST?

HAVING SALAD
STUCK IN YOUR
TEETH AT A
FUNERAL?

ROASTED
BY A
DRAGON?

MOCKED BY
A CHILD ON
NATIONAL
TELEVISION?

FREAK CHEESE-
GRATER ACCIDENT?

TRAMPLED BY
A RHINO?

TRAFFIC JAM WHEN
YOU REALLY NEED
TO PEE?

BLANKING ON
YOUR PIN NUMBER?

FINDING HALF
A WORM IN
YOUR APPLE?

BEING ALLERGIC
TO POTATOES?

TOLD OFF BY A
GRANDMA WHO
ISN'T YOUR GRANDMA?

DISAPPOINTING
A LABRADOR?

SAUSAGES INSTEAD
OF FINGERS?

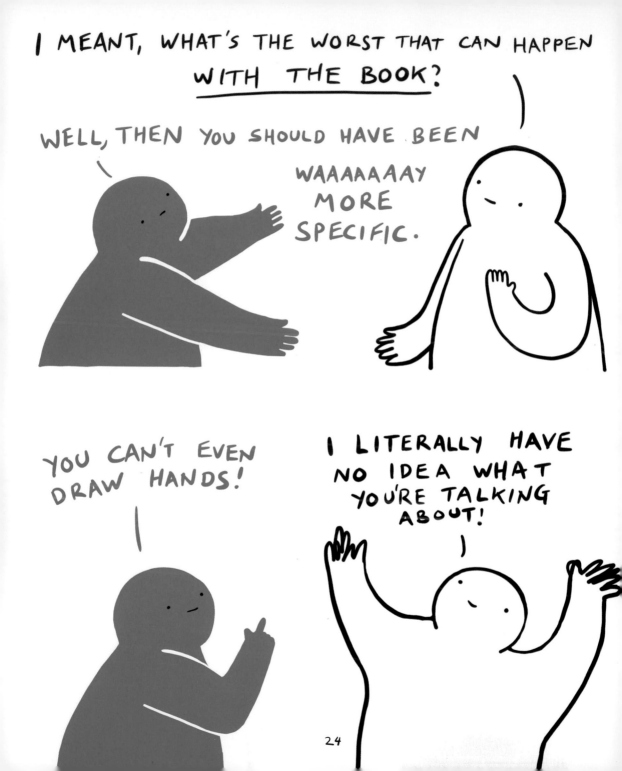

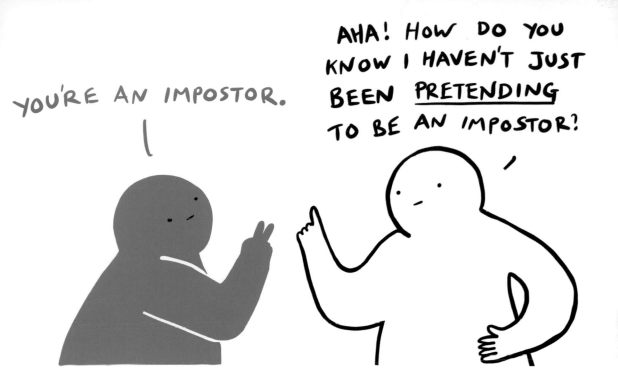

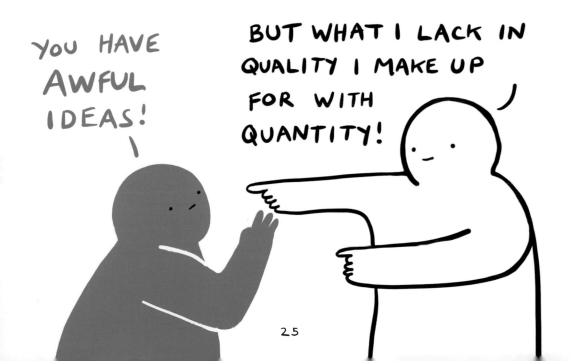

25

BEHOLD!
MY SKETCHBOOKS!

WOW, YOU HAVE EVEN
MORE AWFUL IDEAS
THAN I THOUGHT!

26

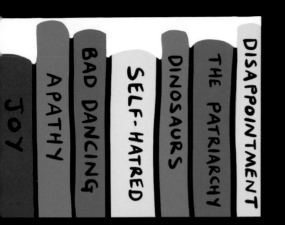
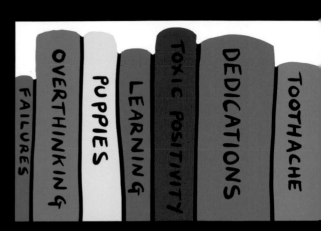
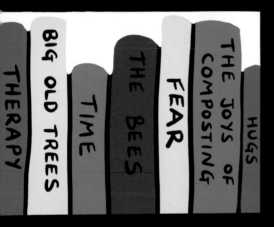

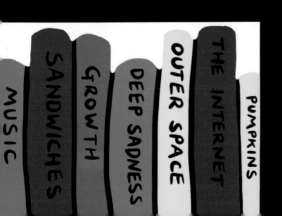

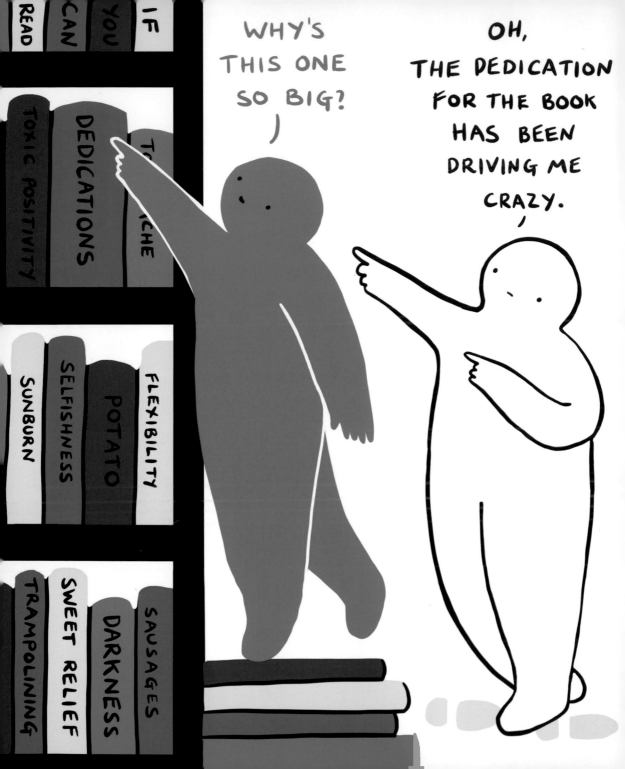

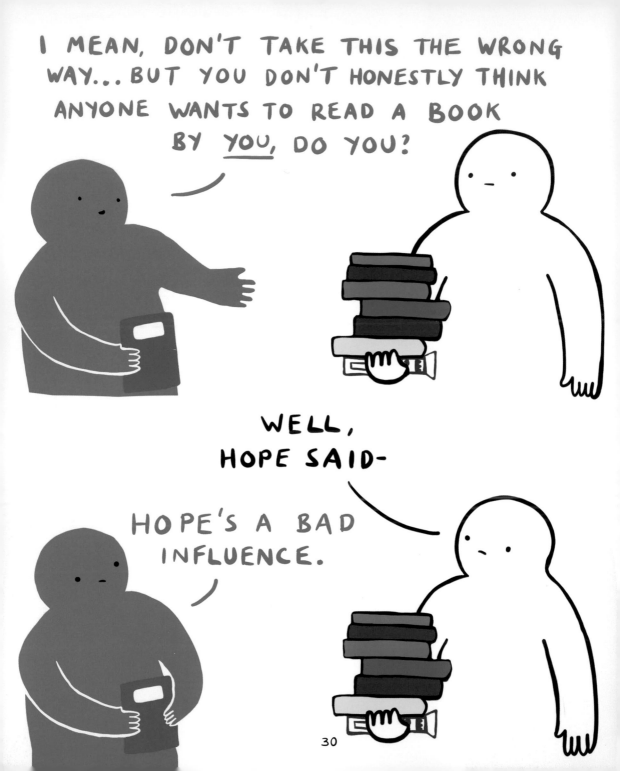

NOW, LET'S TAKE A LOOK AT THESE.

BRAVE WORRIERS

THIS BOOK IS FOR YOU

FEELERS OF MANY FEELINGS

THIS BOOK IS FOR YOU

33

THOSE WHO READ

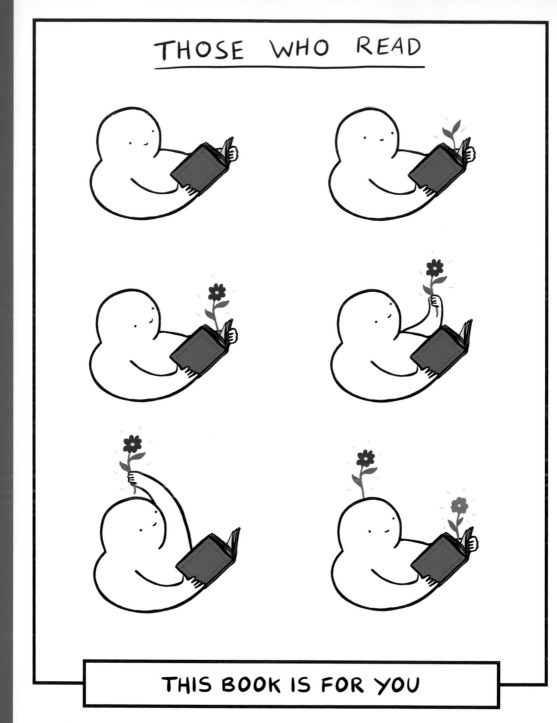

THIS BOOK IS FOR YOU

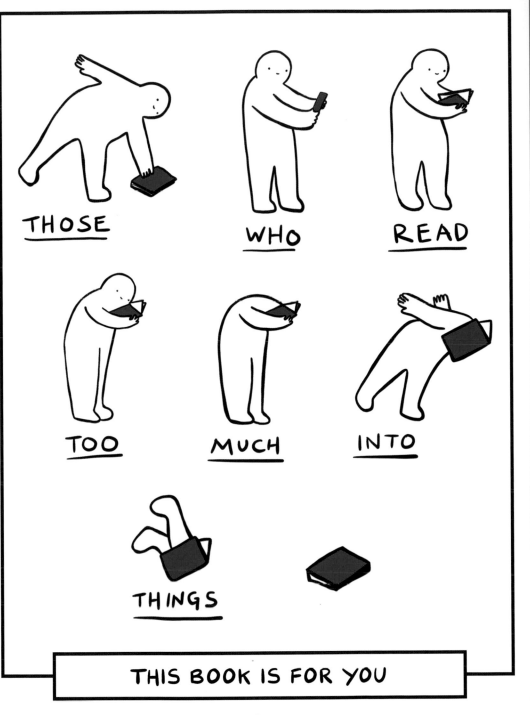

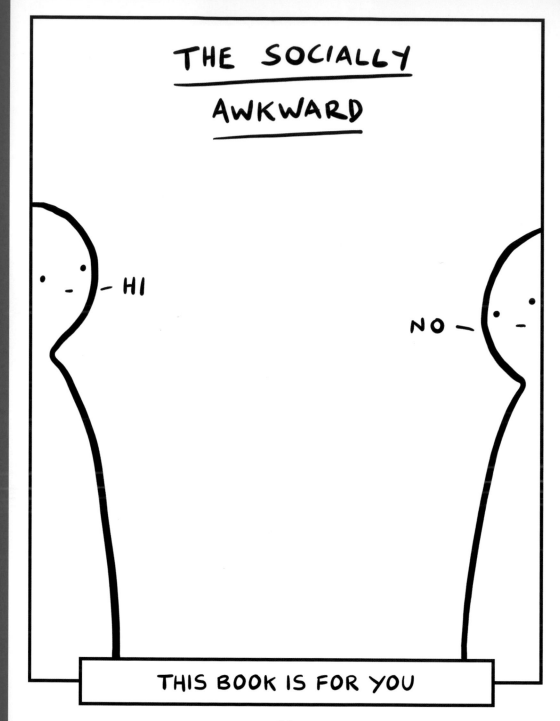

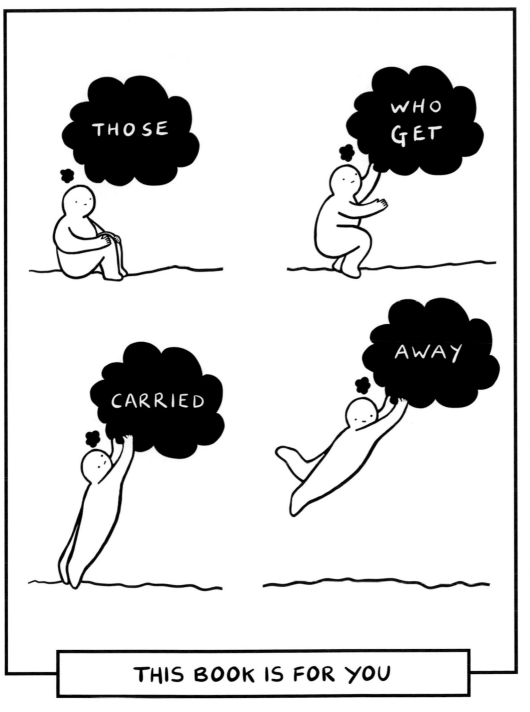

THE HEAVYHEARTED

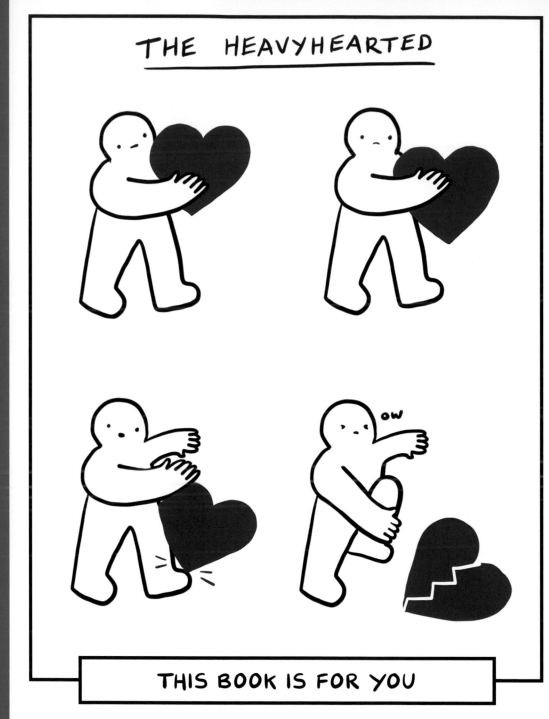

THIS BOOK IS FOR YOU

THE LIGHTHEADED

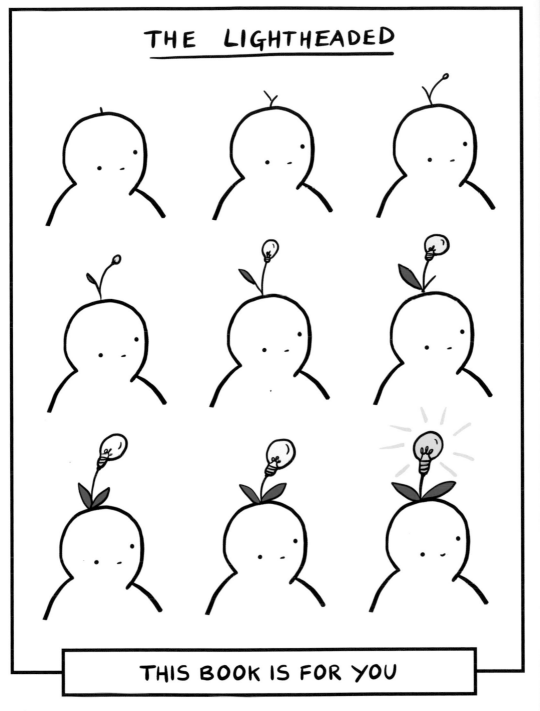

THIS BOOK IS FOR YOU

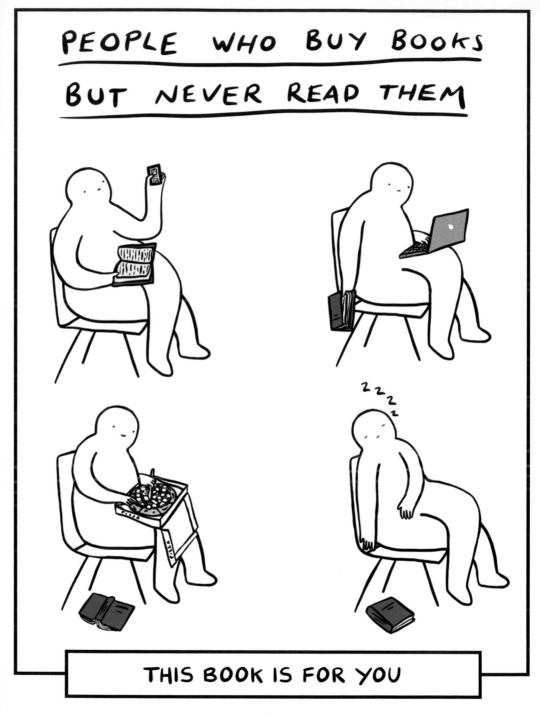

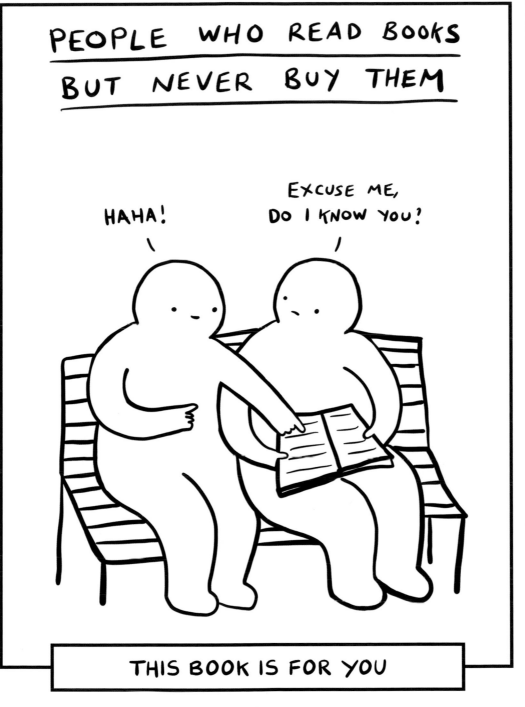

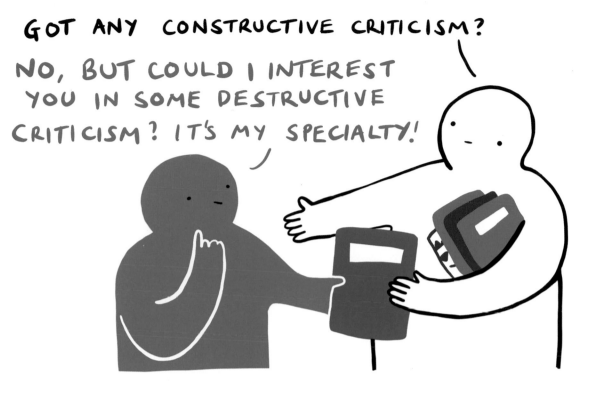

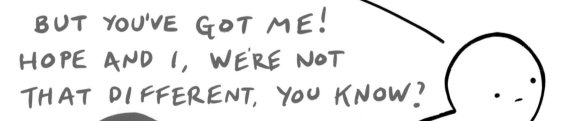

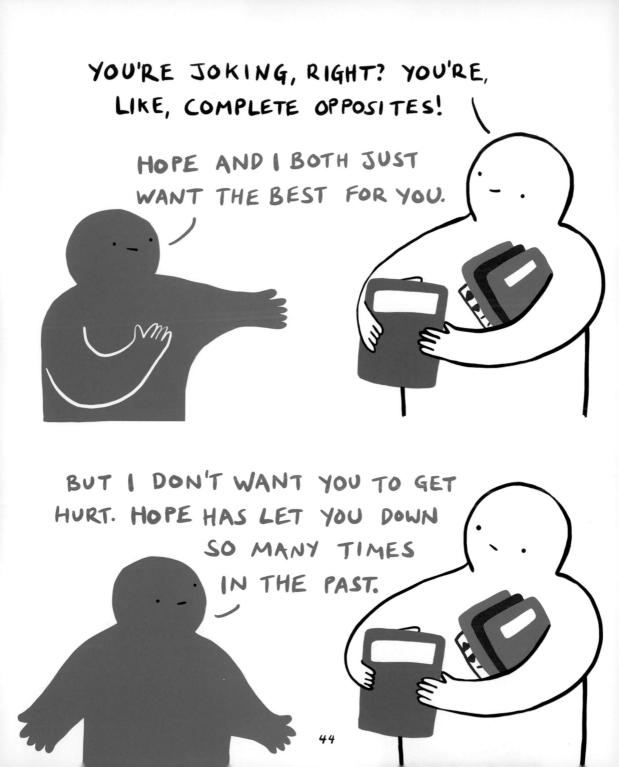

AND MAKING BOOKS IS HARD, EVEN FOR REALLY SMART PEOPLE, SO IMAGINE HOW HARD IT WILL BE FOR YOU!

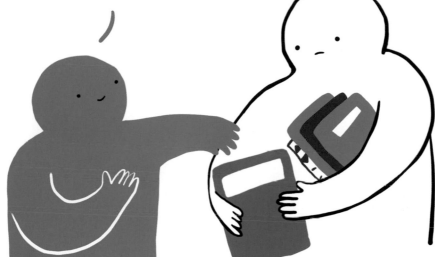

YOU WANT MY ADVICE?

NOT REALLY

"IF YOU DON'T TRY, YOU CAN'T FAIL."

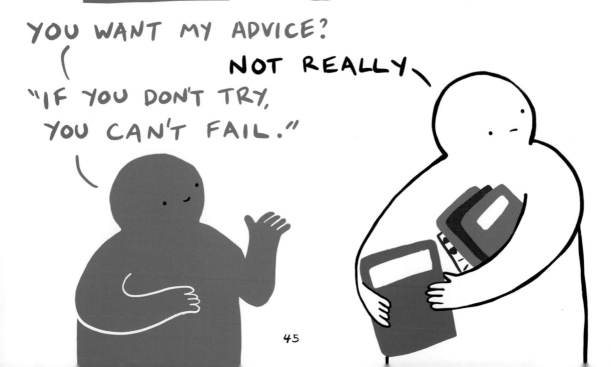

45

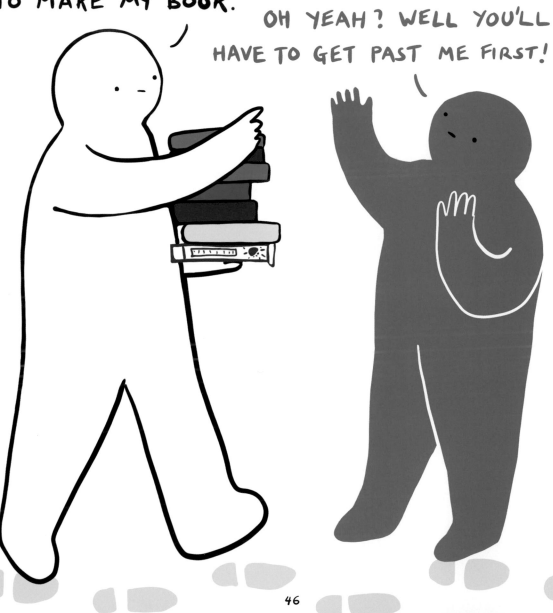

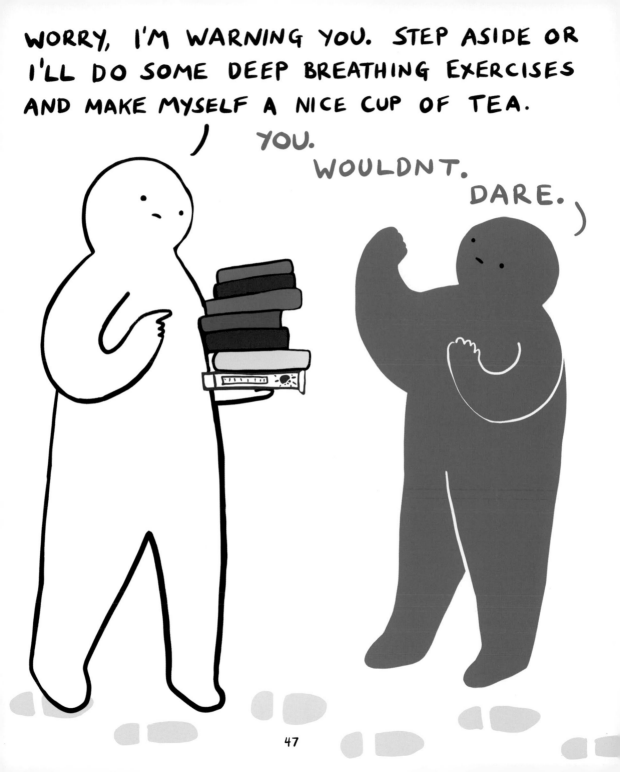

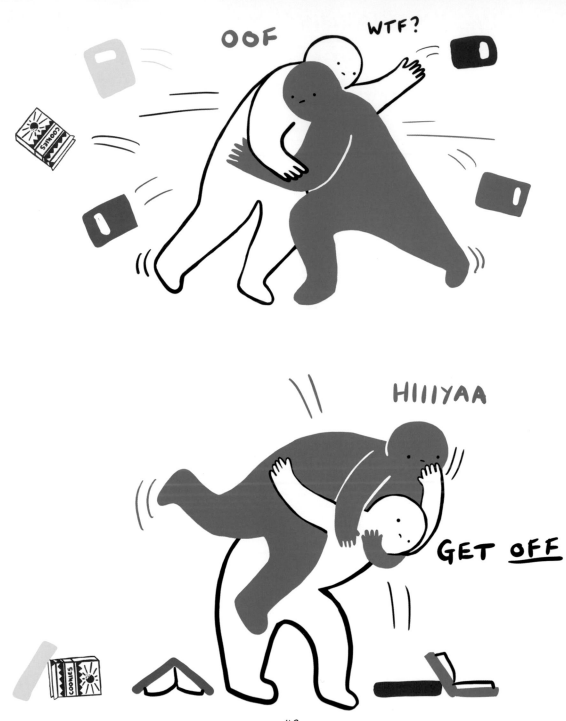

48

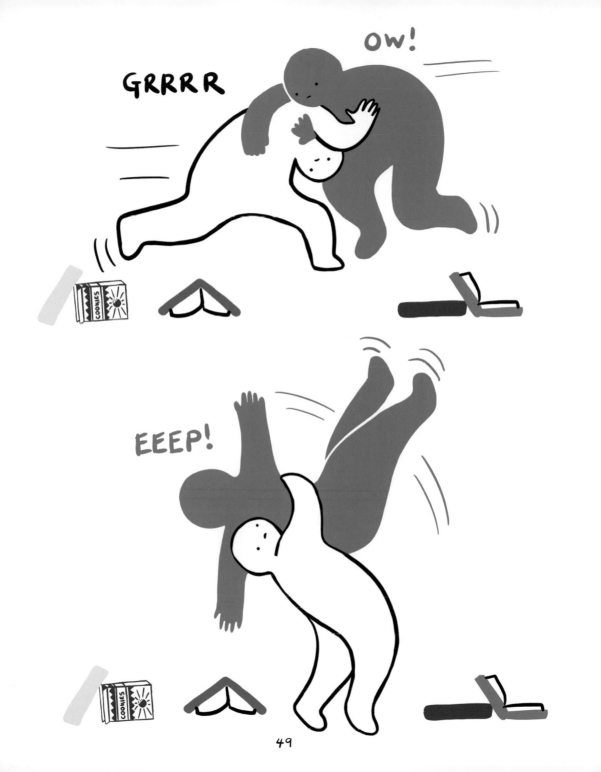

49

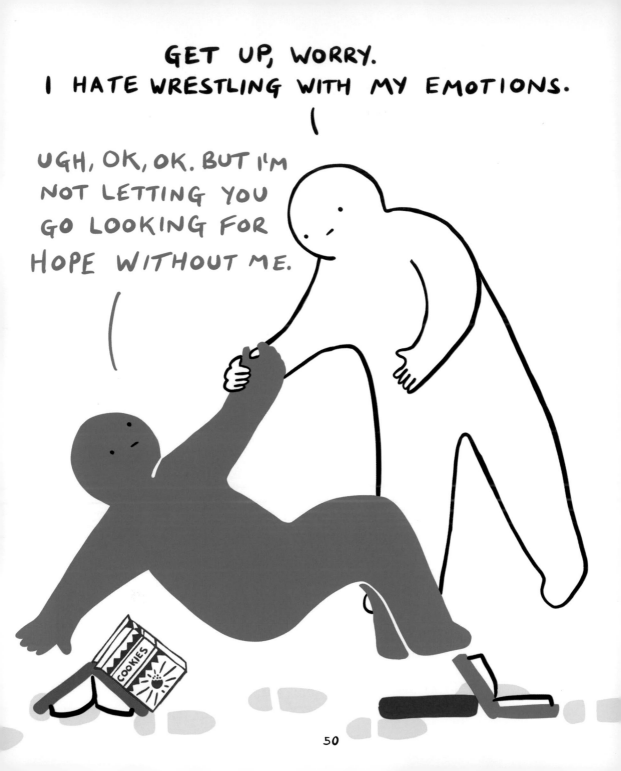

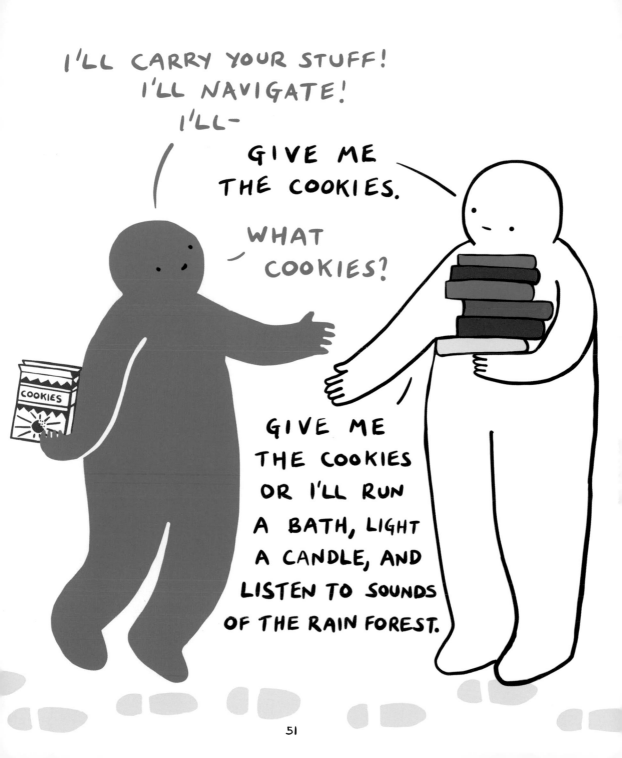

51

SIGH FINE. I'LL GIVE YOU THE COOKIES ON TWO CONDITIONS: 1. I AM COMING WITH YOU TO FIND HOPE.

2. I GET TO EDIT YOUR BOOK ON THE WAY. JUDGING BY WHAT I'VE SEEN SO FAR, YOU NEED ALL THE HELP YOU CAN GET.

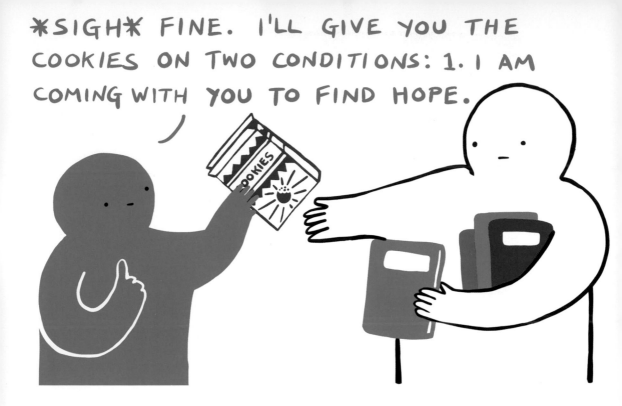

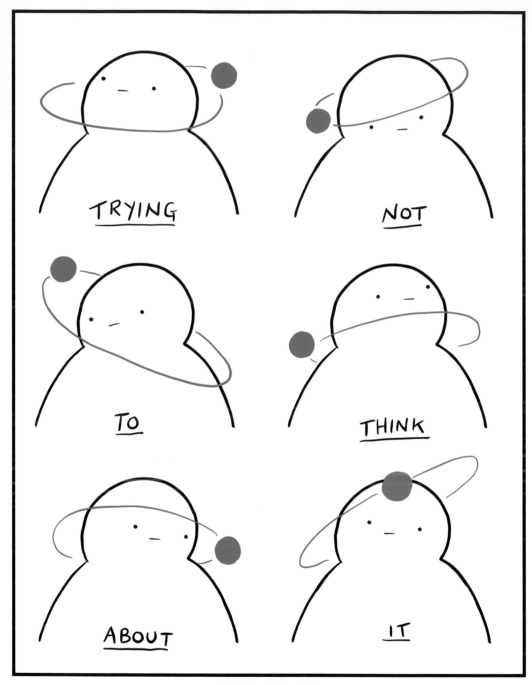

MOSTLY FAILING.

ME TRYING TO GET OUT OF MY OWN HEAD

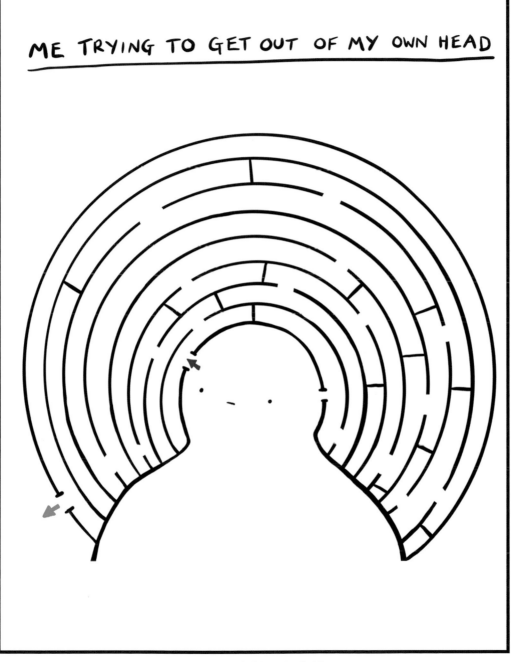

PLAY ALONG AT HOME.

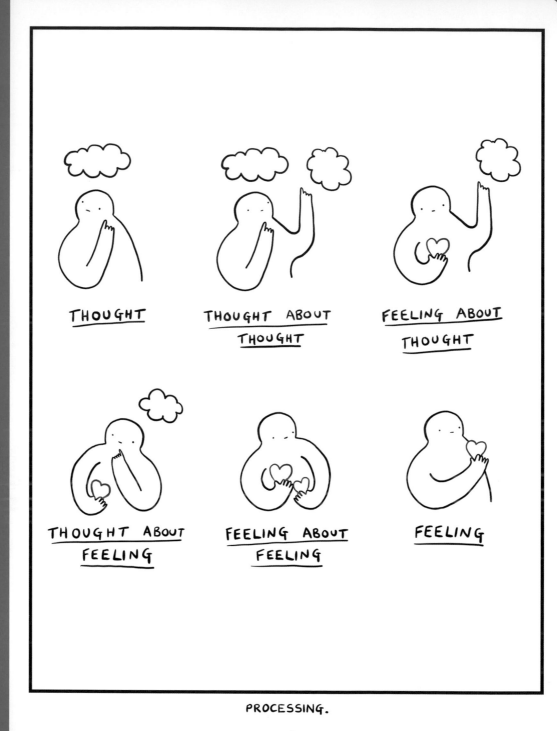

THOUGHT

THOUGHT ABOUT
THOUGHT

FEELING ABOUT
THOUGHT

THOUGHT ABOUT
FEELING

FEELING ABOUT
FEELING

FEELING

PROCESSING.

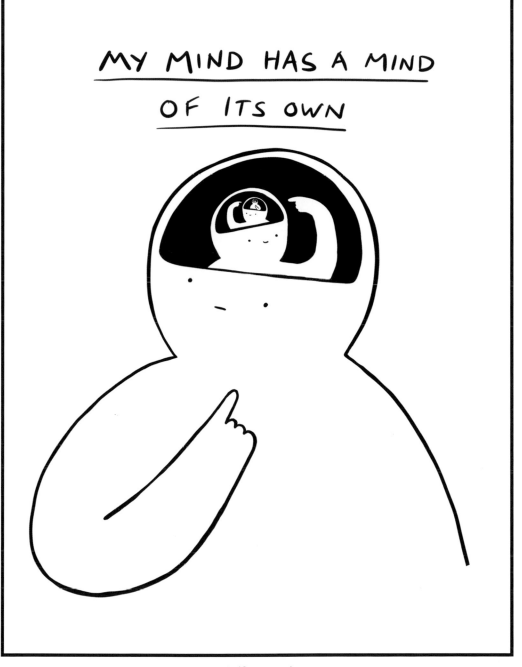

MY MIND HAS A MIND OF ITS OWN

AND SO ON.

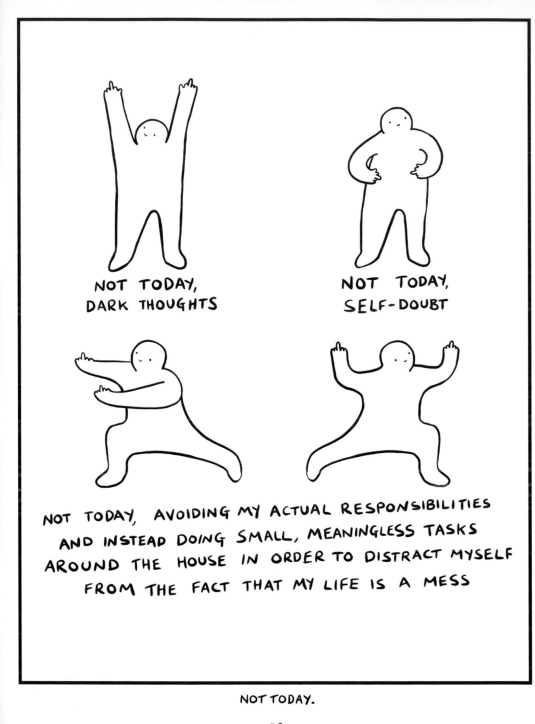

NOT TODAY,
DARK THOUGHTS

NOT TODAY,
SELF-DOUBT

NOT TODAY, AVOIDING MY ACTUAL RESPONSIBILITIES
AND INSTEAD DOING SMALL, MEANINGLESS TASKS
AROUND THE HOUSE IN ORDER TO DISTRACT MYSELF
FROM THE FACT THAT MY LIFE IS A MESS

NOT TODAY.

MENTAL HEALTH.

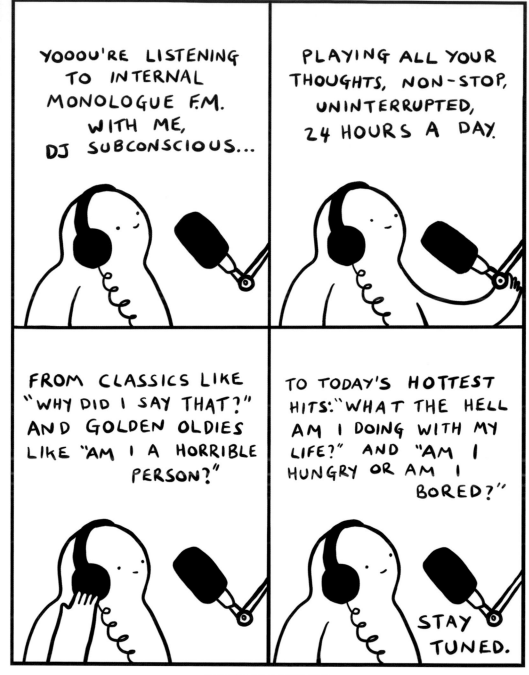

NONSTOP BANGERS.

HERE WE GO AGAIN.

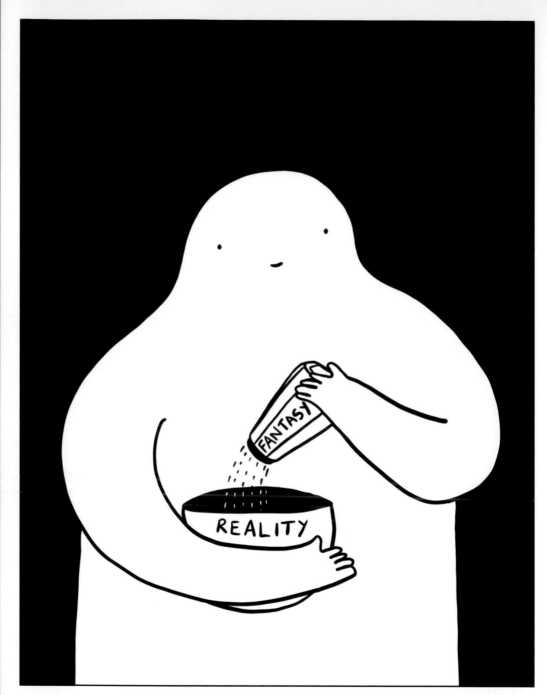

SECRET INGREDIENT.

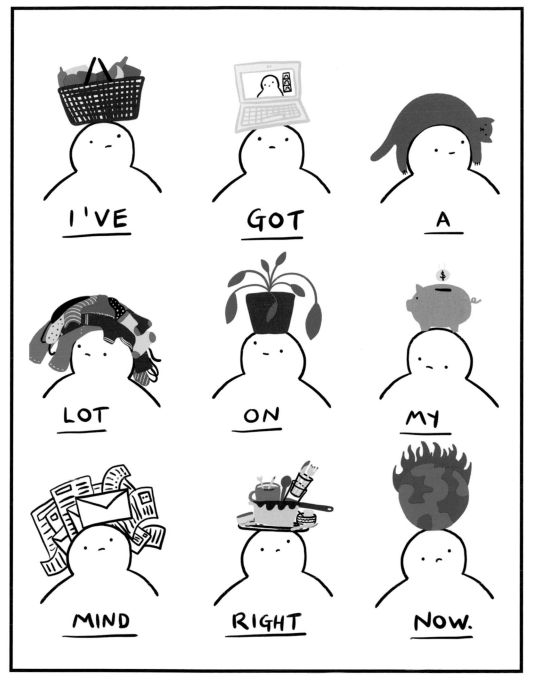

MENTAL LOAD.

TRYING TO GET THE DARK THOUGHTS OUT OF MY MIND

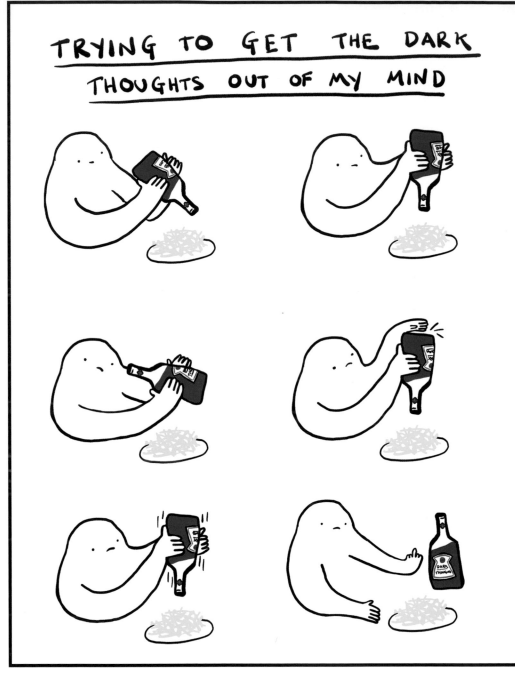

SAUCE OF FRUSTRATION.

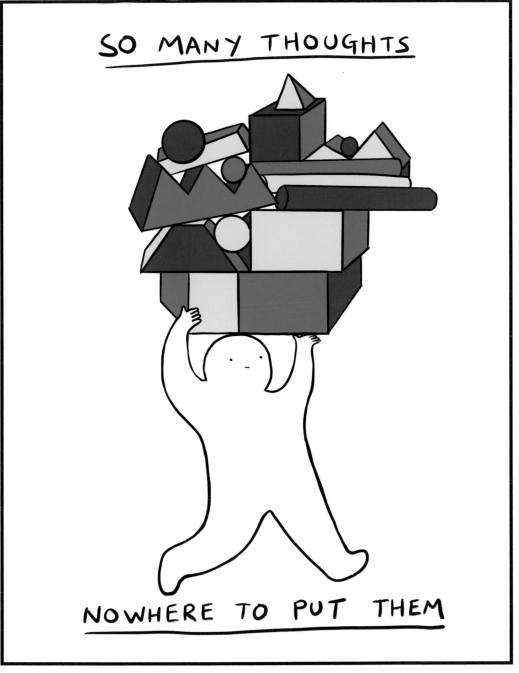

NEED MORE HEADSPACE.

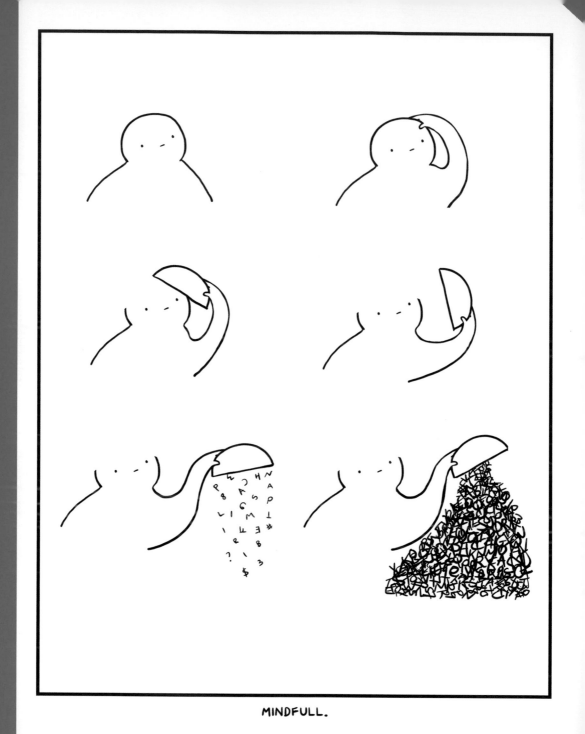

MINDFULL.

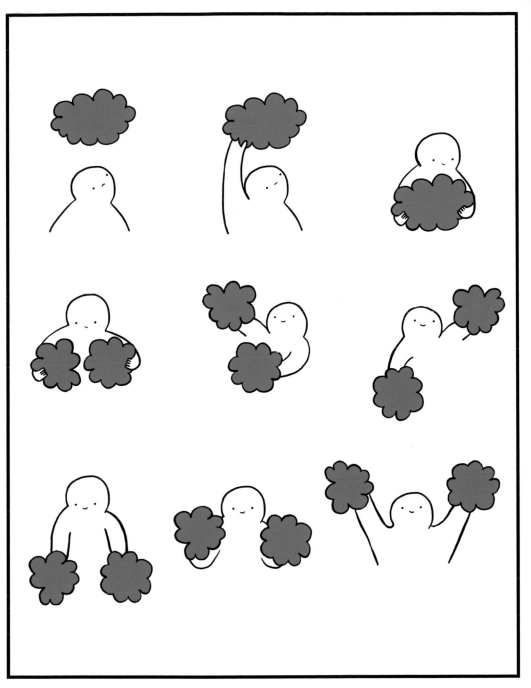

SELF-ENCOURAGEMENT.

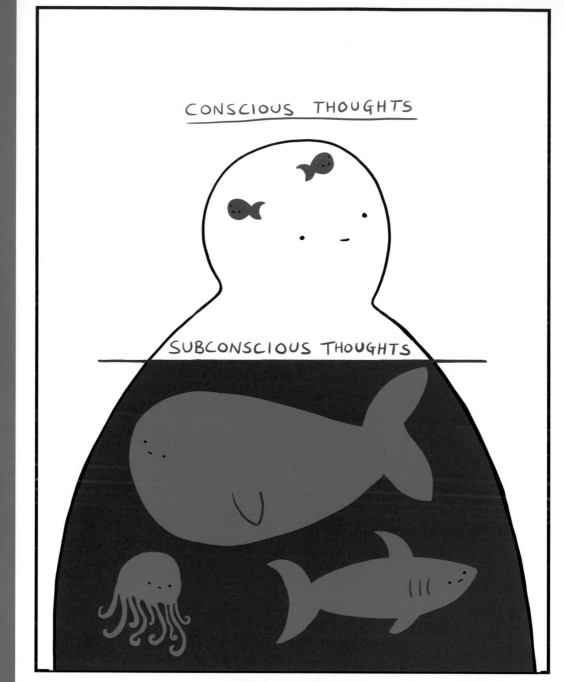

SCHOOL OF THOUGHT.

TRYING TO HOLD THAT THOUGHT

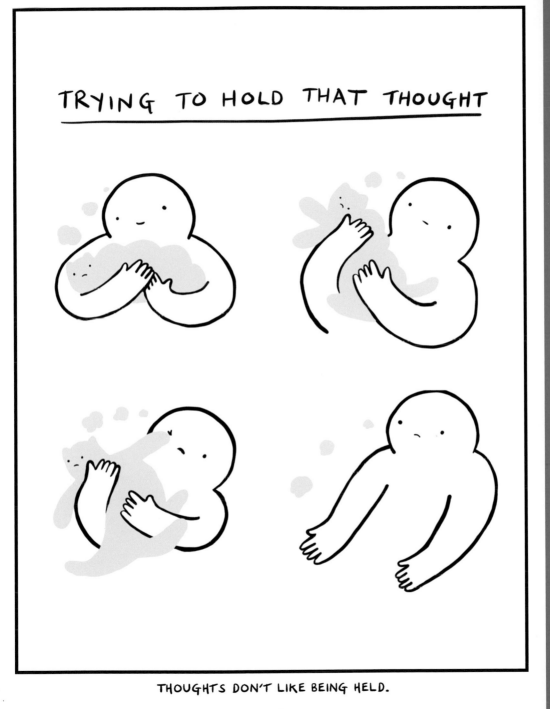

THOUGHTS DON'T LIKE BEING HELD.

OK! FINISHED! THANKS FOR THE LIFT—TURNS OUT WALKING WHILE READING IS REALLY HARD.

HMPFH

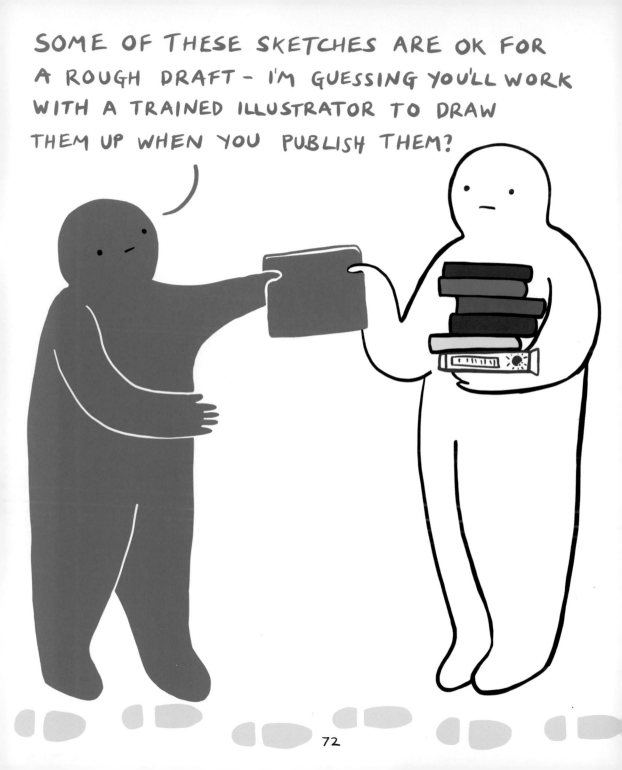

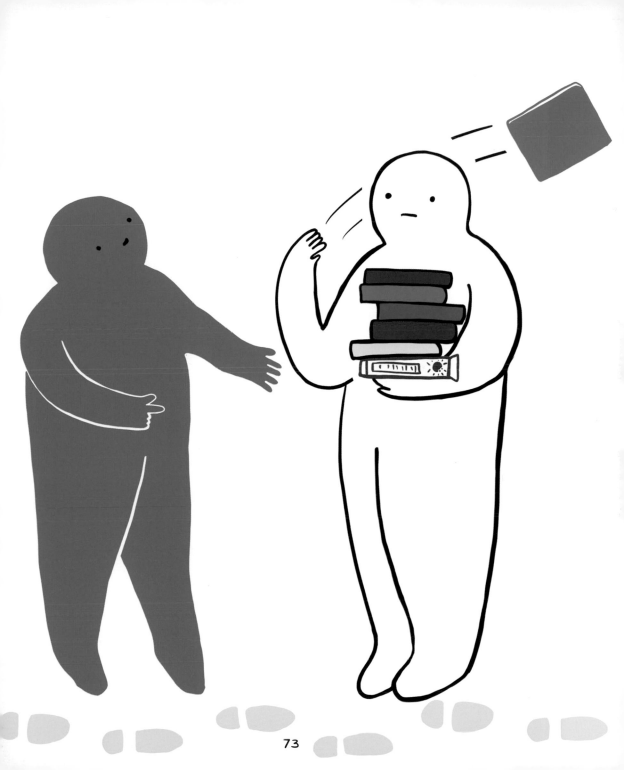

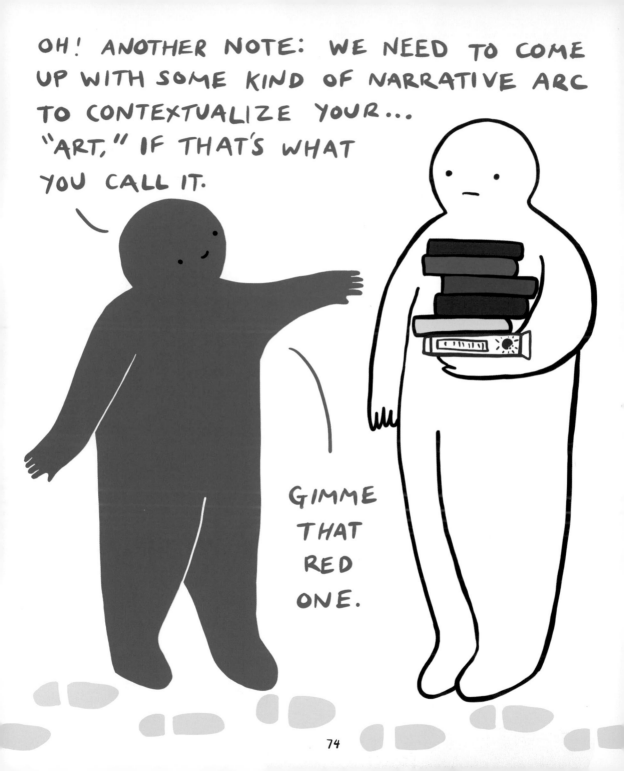

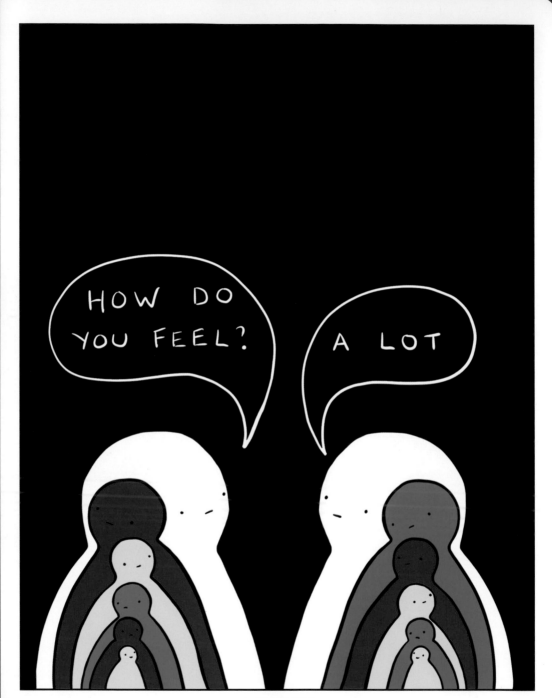

AND OFTEN.

HOUSTON, WE HAVE A PROBLEM.

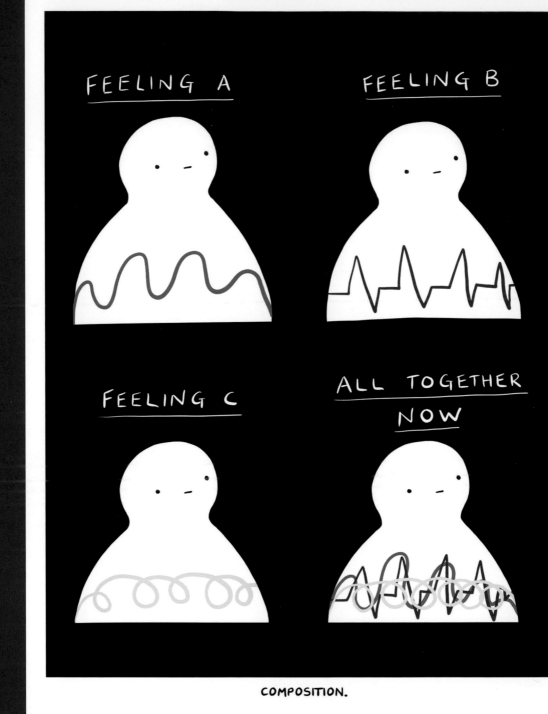

COMPOSITION.

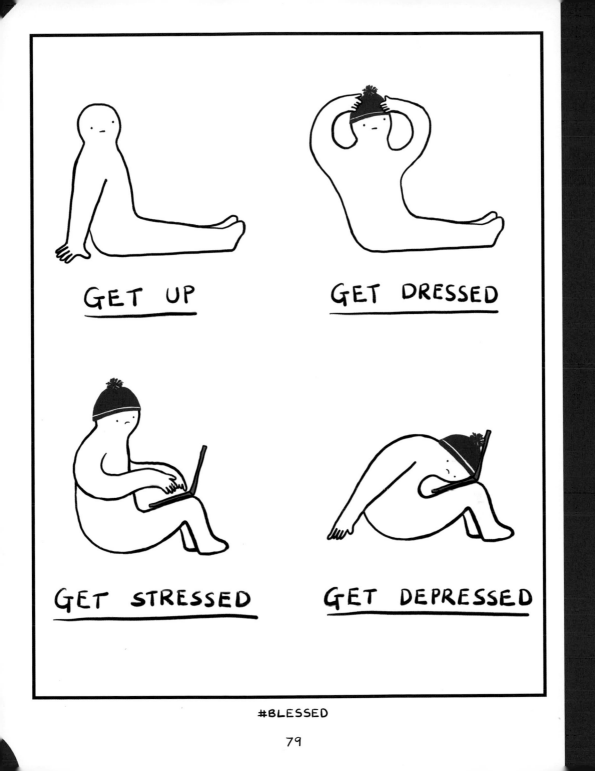

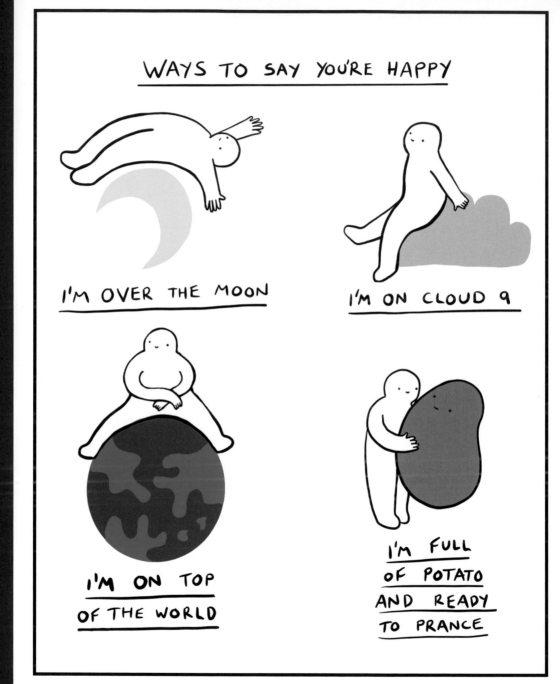

WAYS TO SAY YOU'RE HAPPY

I'M OVER THE MOON

I'M ON CLOUD 9

I'M ON TOP OF THE WORLD

I'M FULL OF POTATO AND READY TO PRANCE

I MADE ONE OF THEM UP.

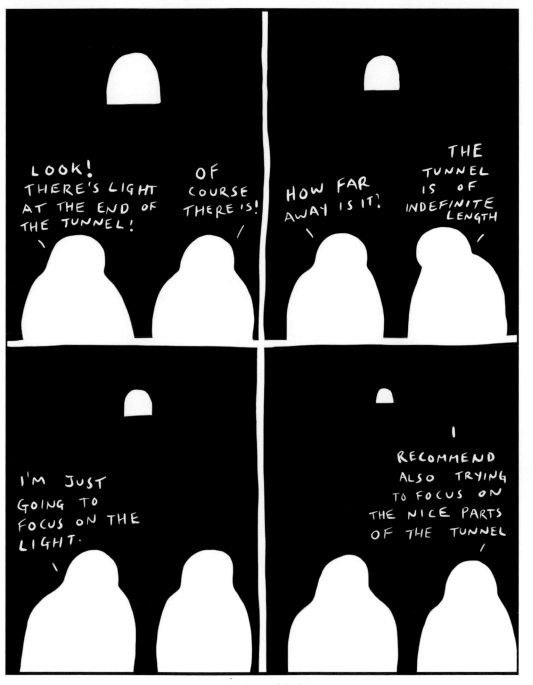

TUNNEL VISION.

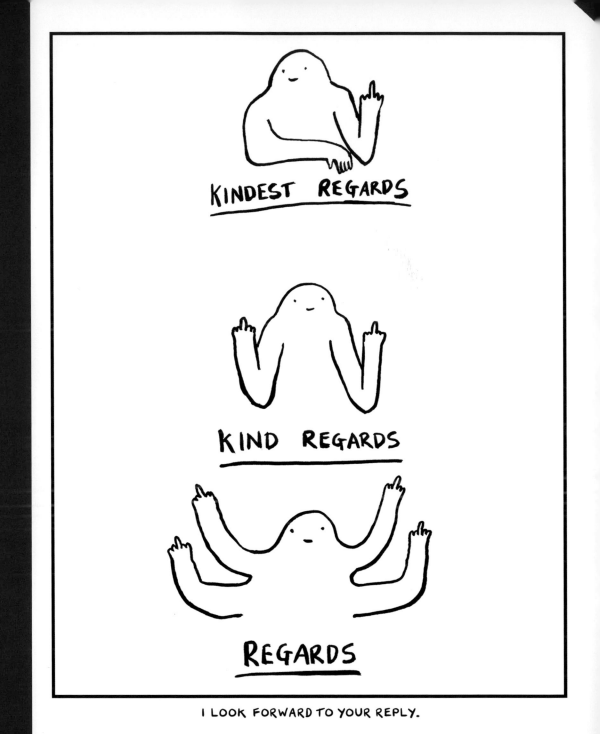

I LOOK FORWARD TO YOUR REPLY.

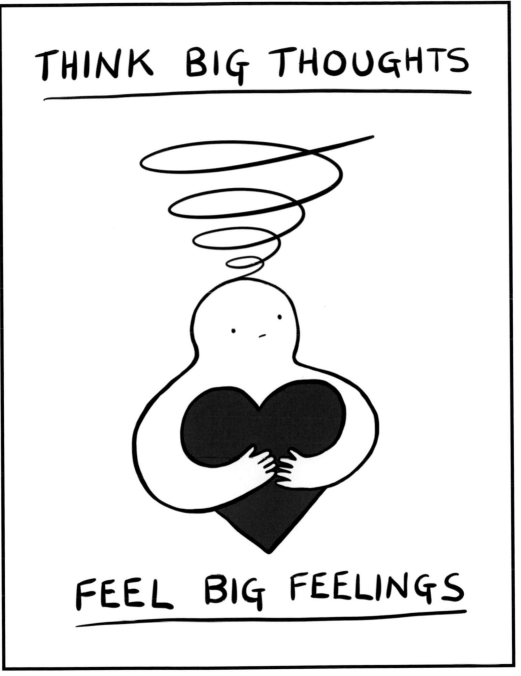

GO BIG OR GO HOME.

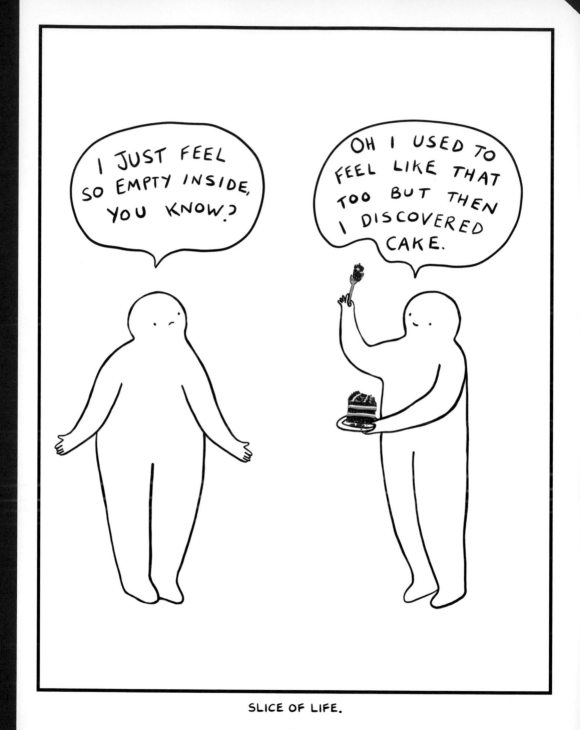

SLICE OF LIFE.

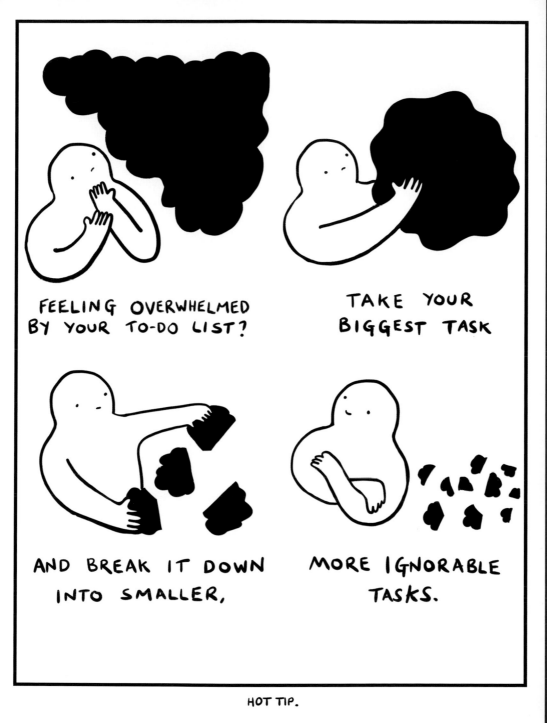

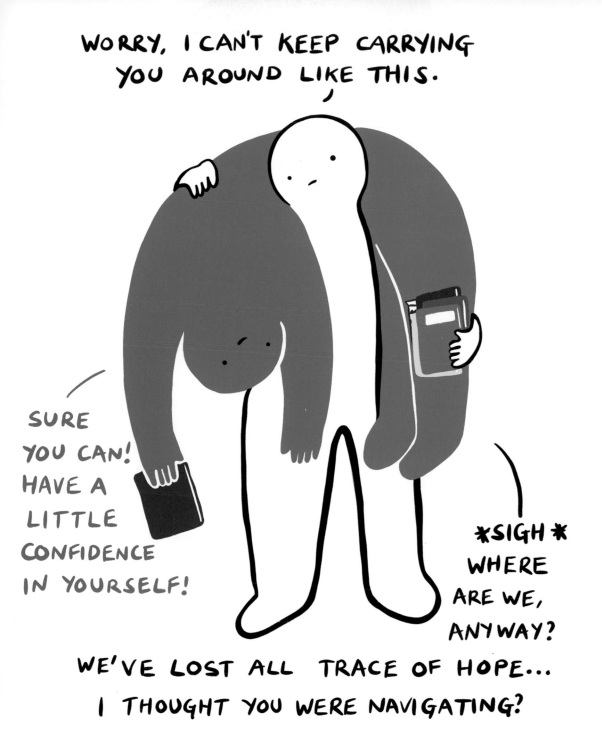

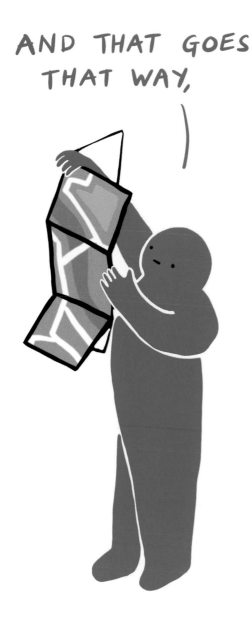

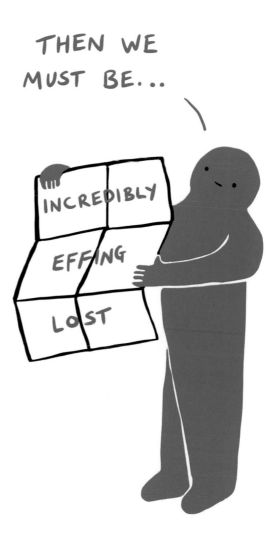

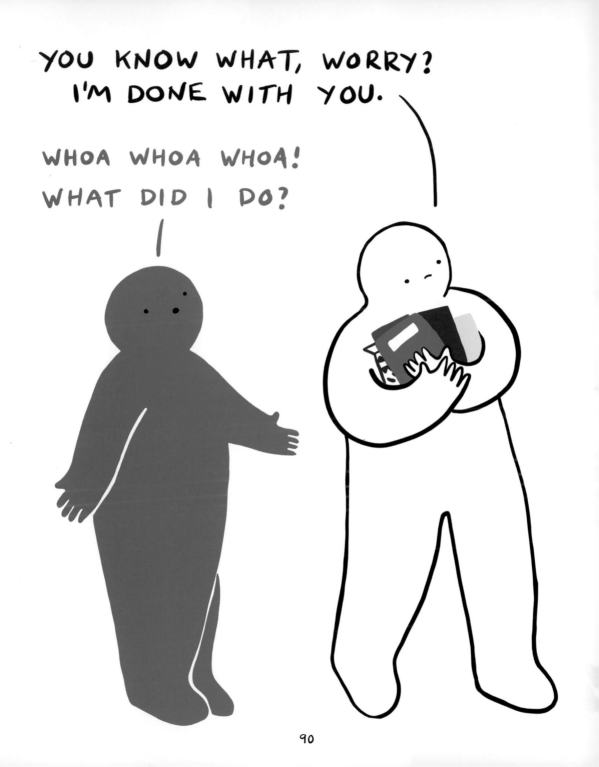

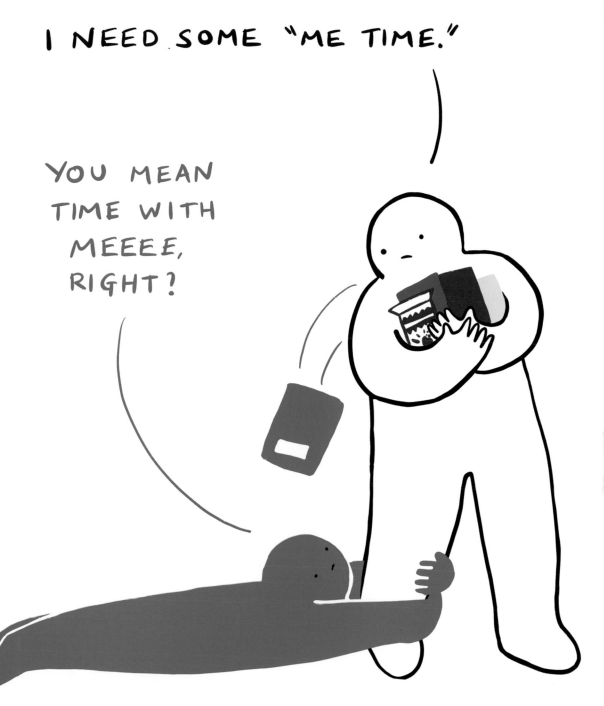

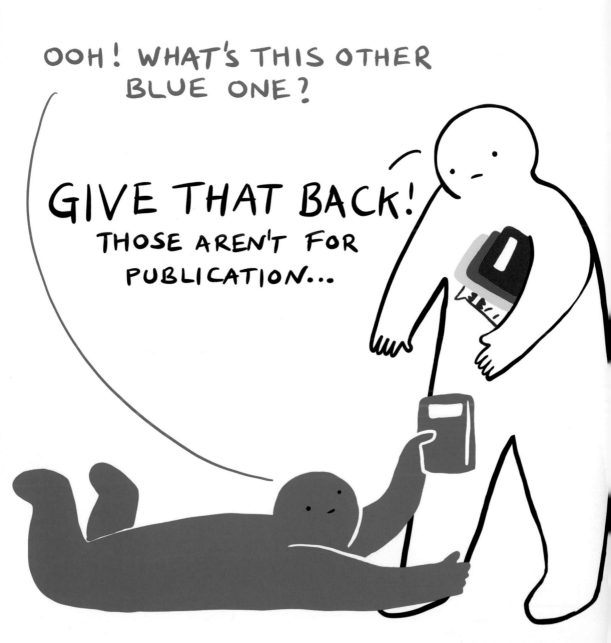

THESE ARE ABOUT...ME?

DRAWINGS ABOUT
WORRY

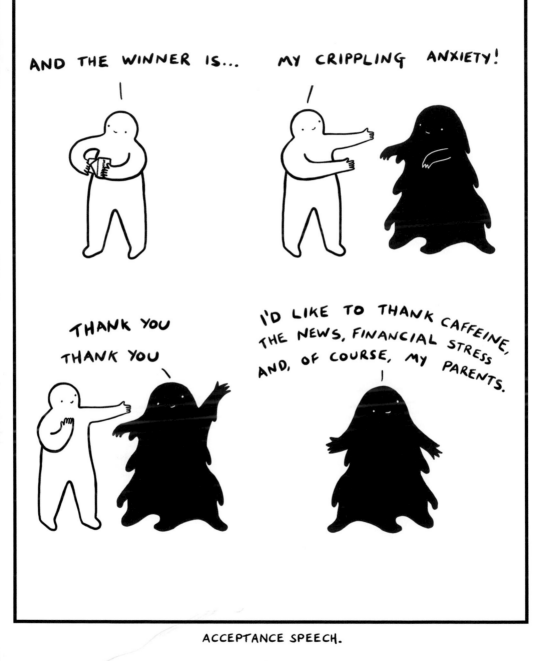

ACCEPTANCE SPEECH.

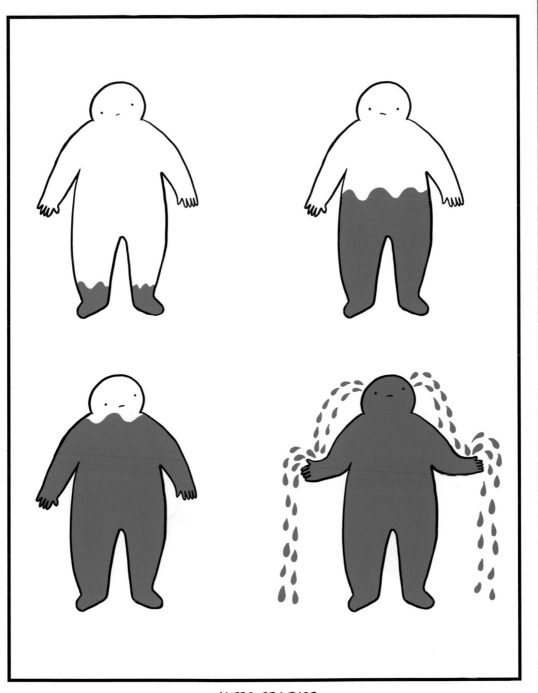

WATER FEATURE.

OH NO, NOT YOU AGAIN. WHAT DO YOU WANT?

I'VE ALREADY GIVEN YOU FOOD, WATER, EXERCISE, THERAPY, MEDS, TWO BATHS, TWO NAPS...

WHAT MORE COULD YOU POSSIBLY WANT FROM ME?

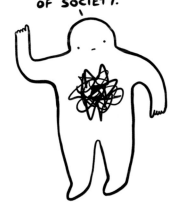

NO. WE CANNOT FAKE OUR OWN DEATH AND RUN AWAY AND START A NEW LIFE IN THE WILDERNESS, FAR FROM THE PRESSURES OF SOCIETY.

AS MUCH AS WE MIGHT WANT TO.

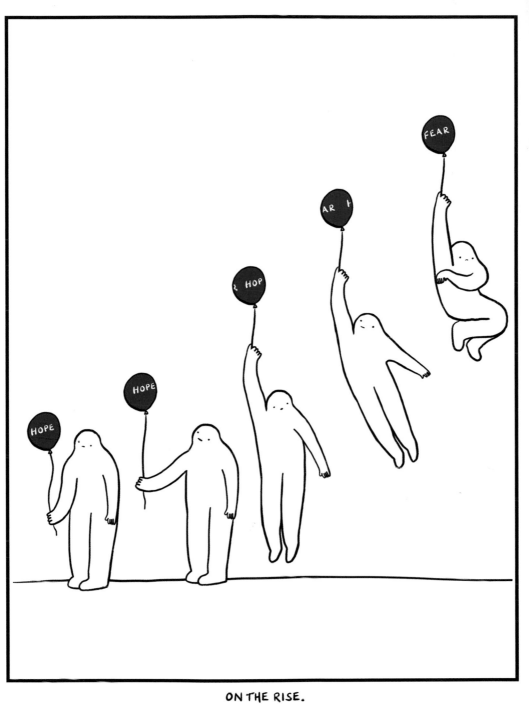

ON THE RISE.

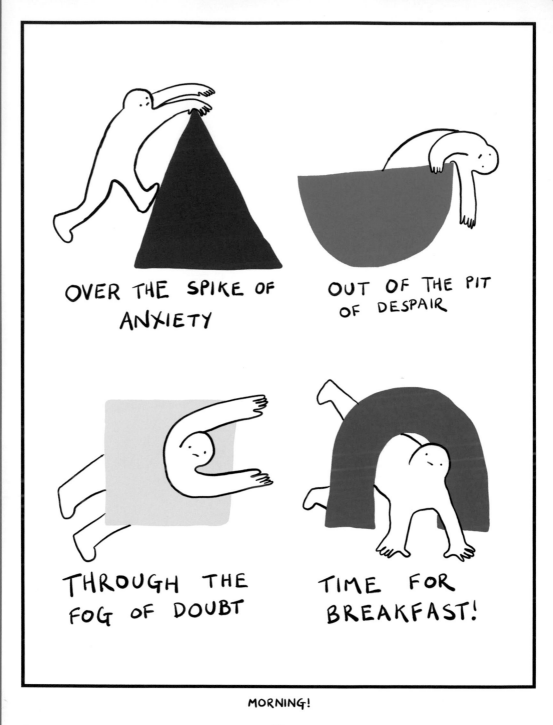

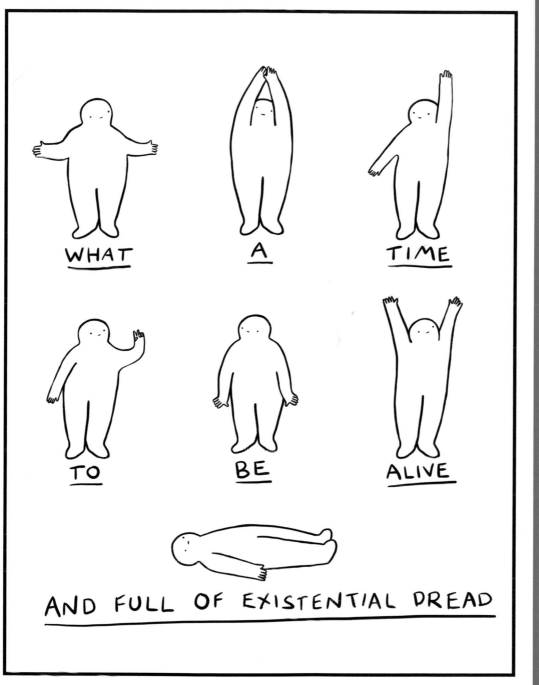

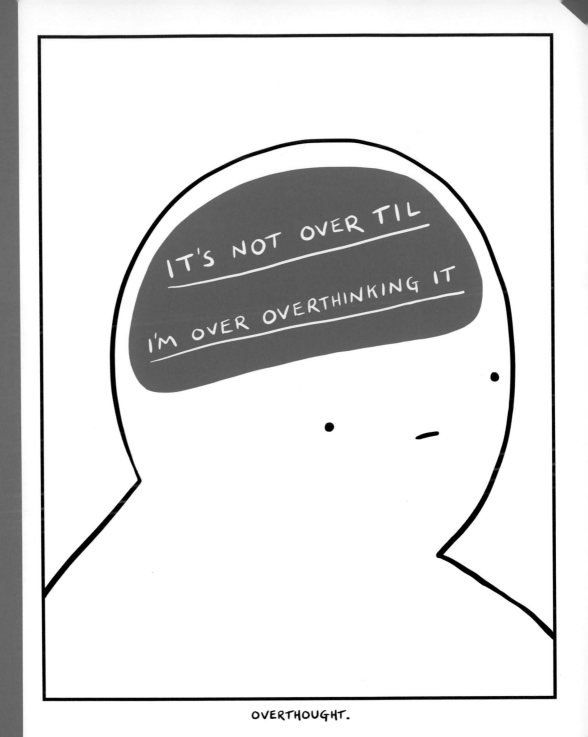

OVERTHOUGHT.

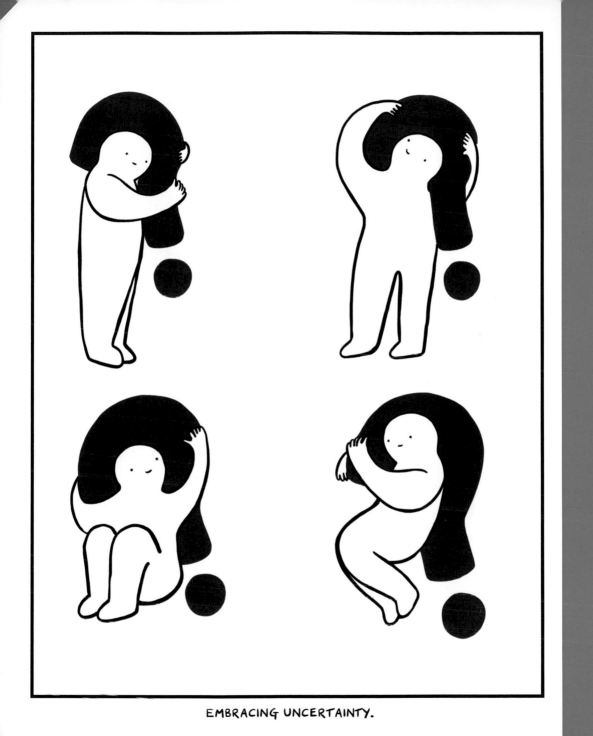

EMBRACING UNCERTAINTY.

ANXIETY USES BRAIN AS BEANBAG

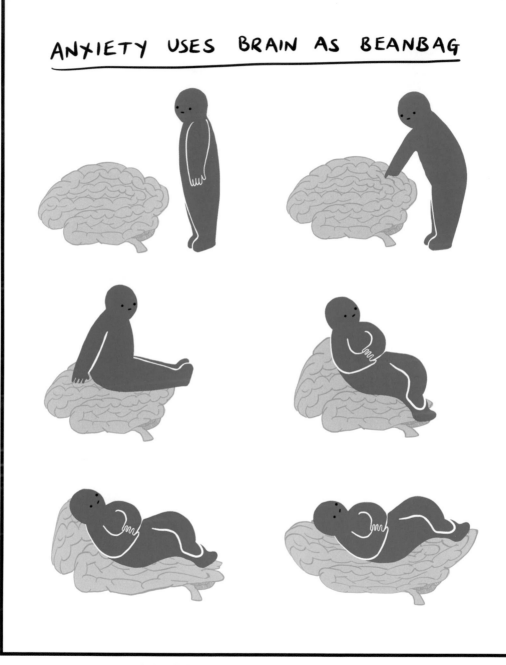

STRUGGLES TO GET BACK UP AGAIN.

TRYING TO FILL THE VOID

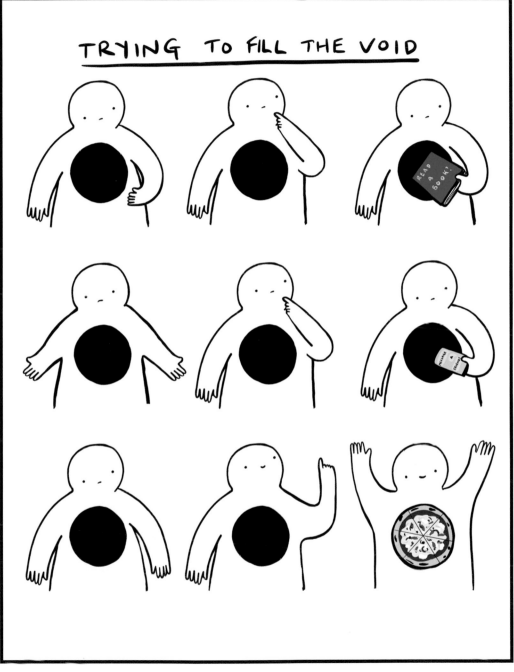

PERFECT FIT.

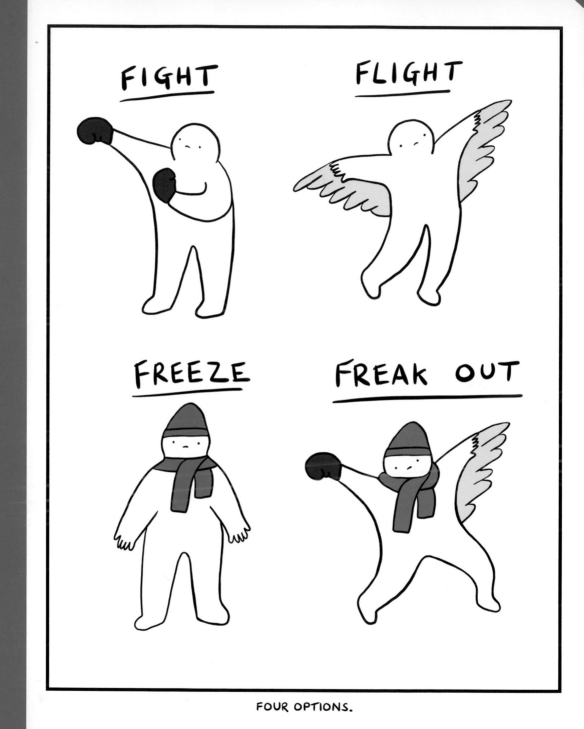

FOUR OPTIONS.

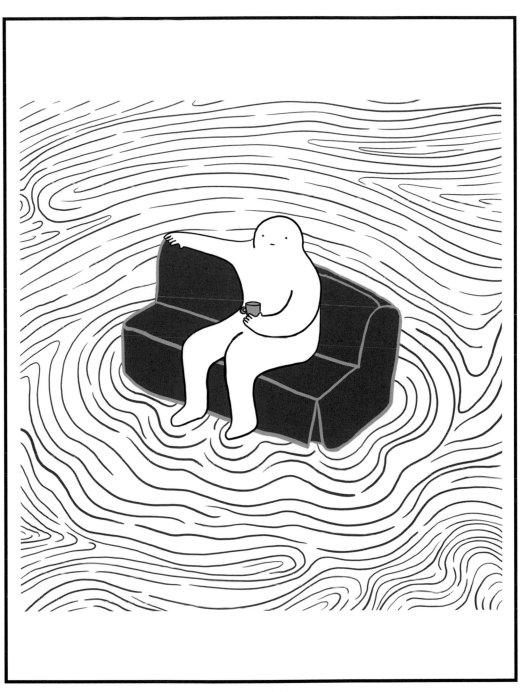

AT SEA.

105

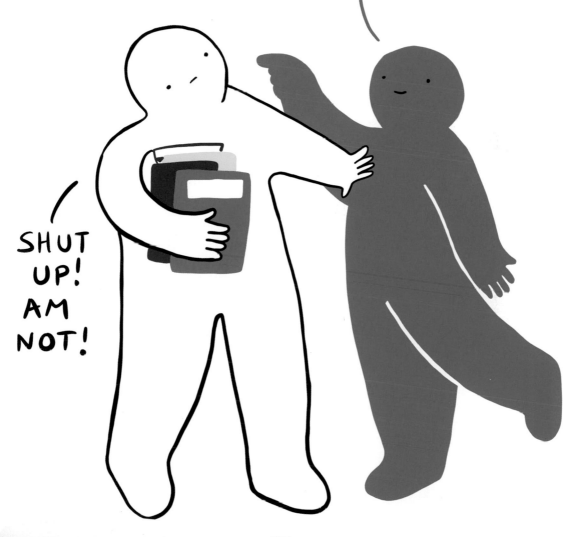

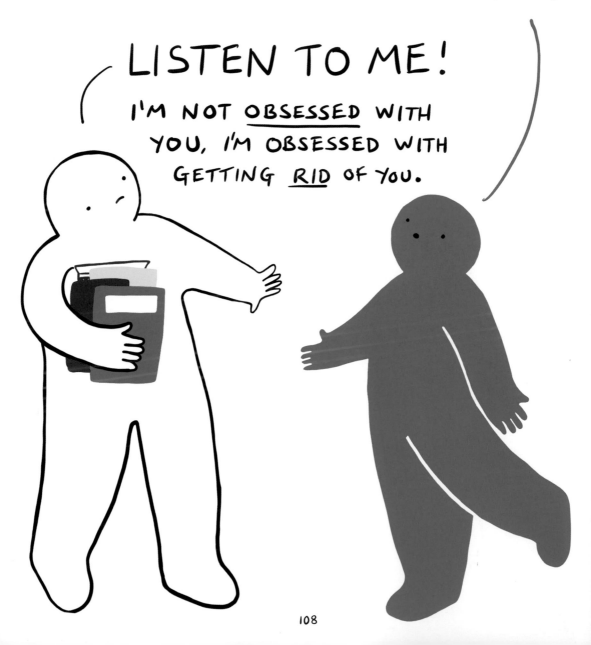

(THIS PAGE HAS BEEN INTENTIONALLY LEFT
BLANK IN ORDER TO REPRESENT A
STUNNED AND AWKWARD SILENCE.)

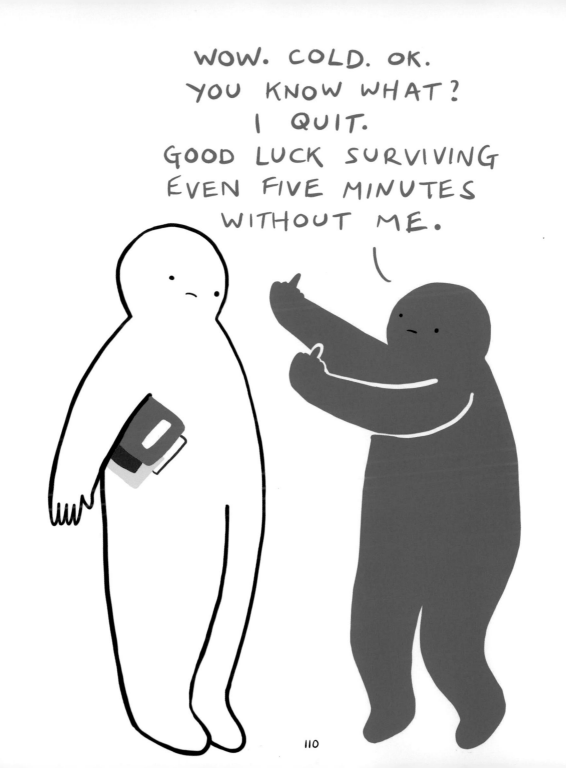

AND DON'T EVEN <u>THINK</u> ABOUT
TRYING TO FOLLOW ME - I'M A
MASTER OF STEALTH AND-OH
SHIT!

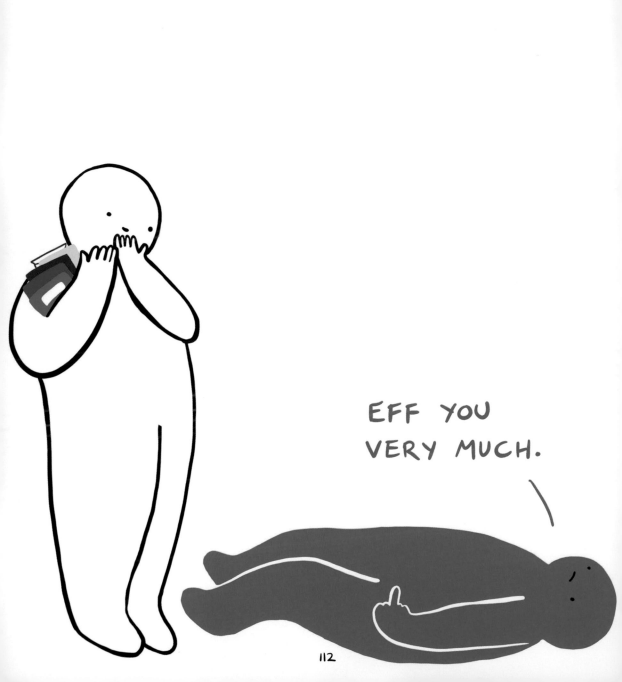

EFF YOU
VERY MUCH.

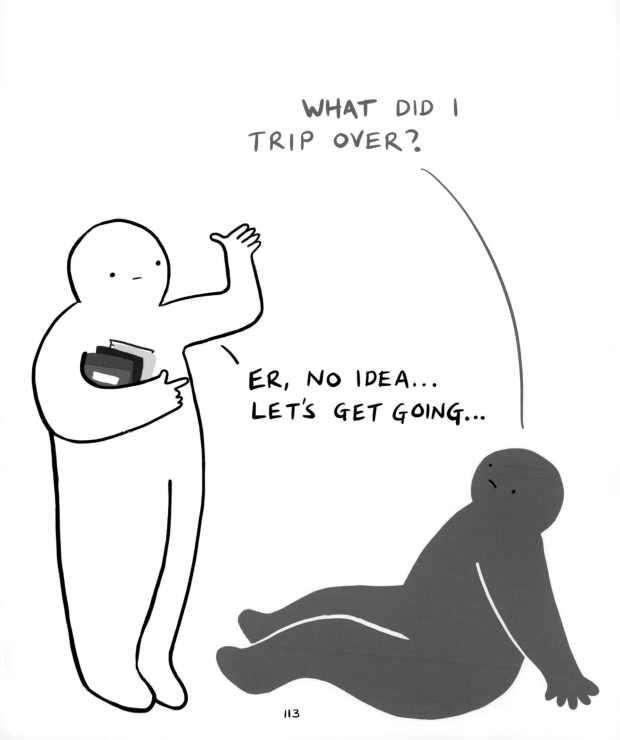

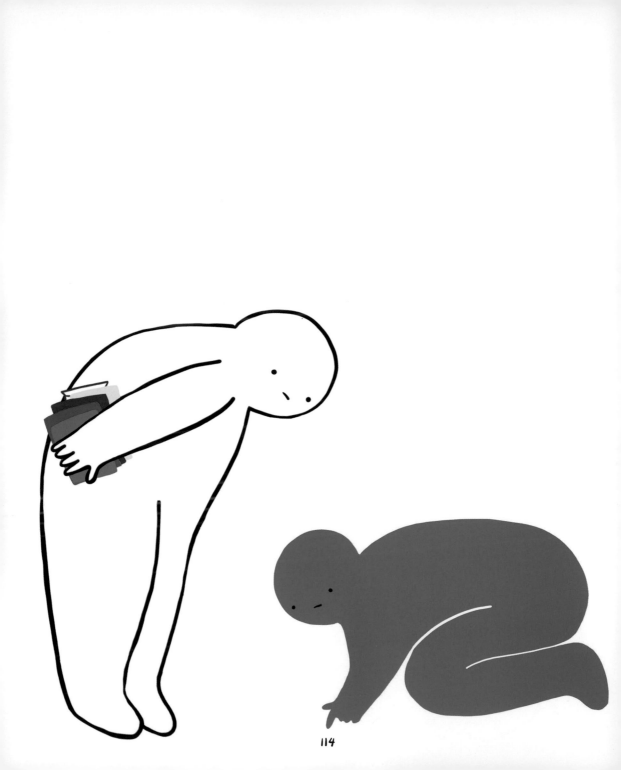

114

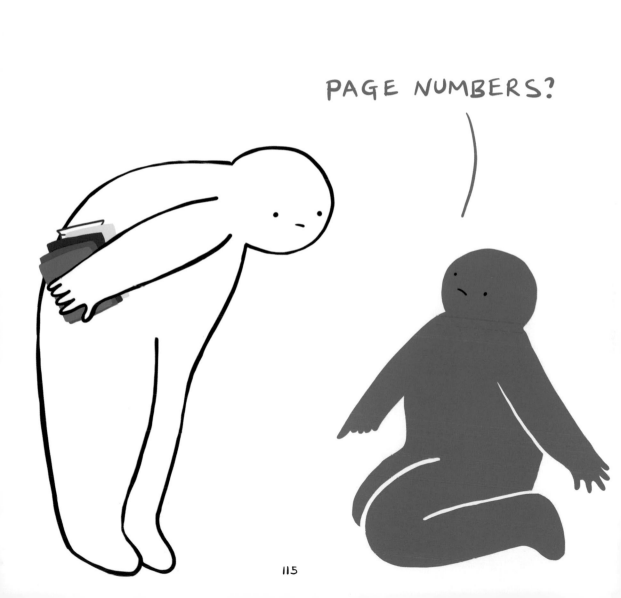

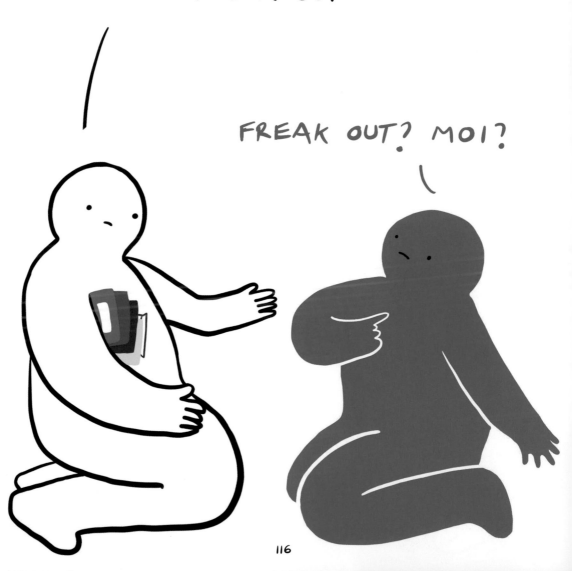

I JUST DON'T WANT YOU TO WORRY...

I SWEAR, IF ONE MORE PERSON TELLS ME TO STOP WORRYING, I'LL PROBABLY HAVE A PANIC ATTACK.

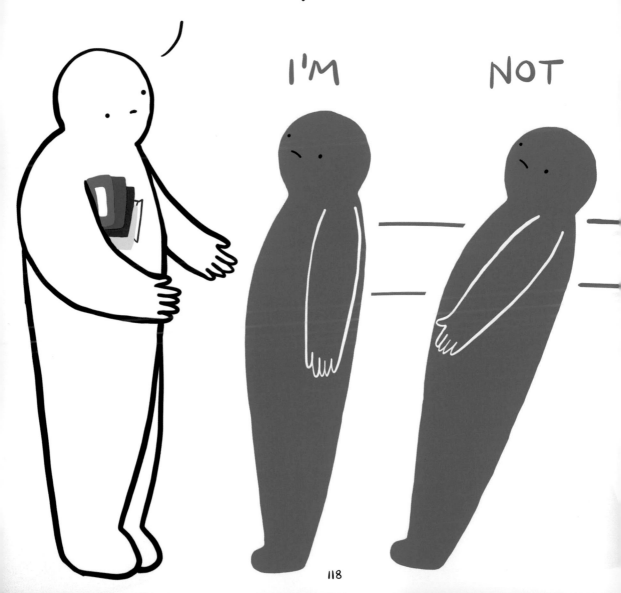

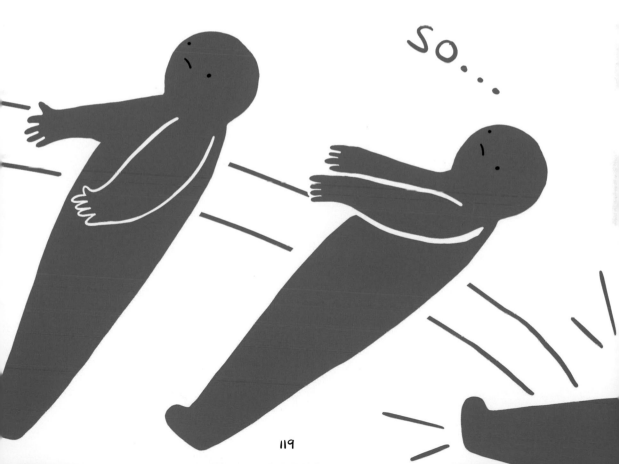

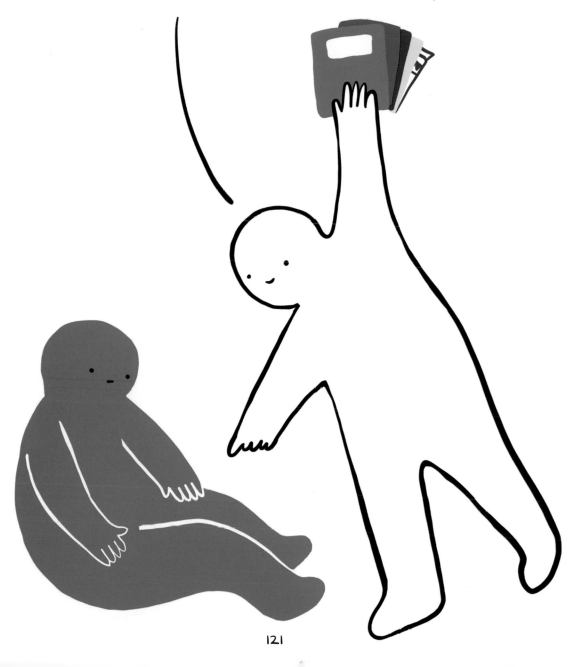

121

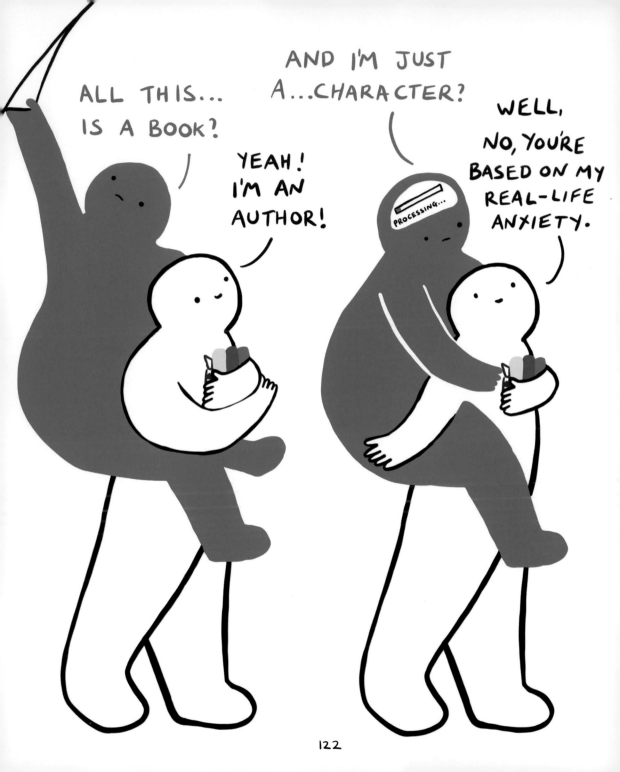

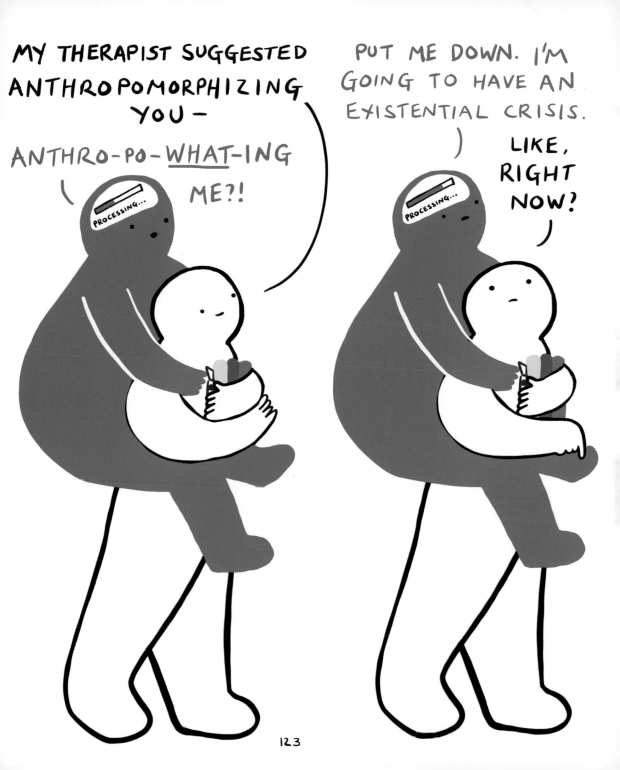

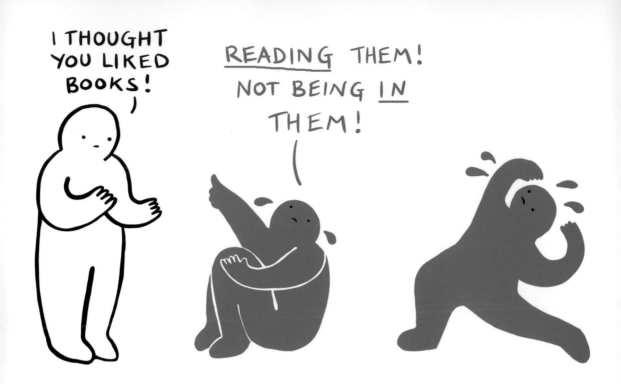

I CANNOT BELIEVE
YOU'RE STILL SEEING
THAT THERAPIST,
AFTER EVERYTHING
I'VE DONE FOR YOU!

YOU'RE
OVERREACTING!

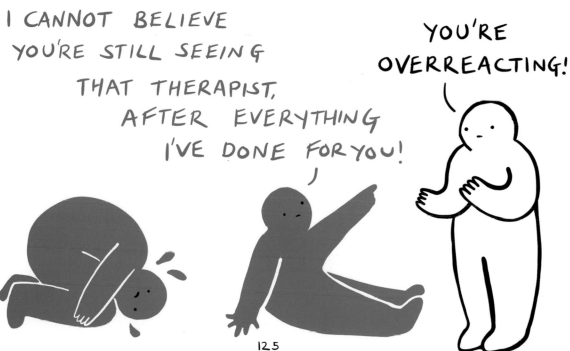

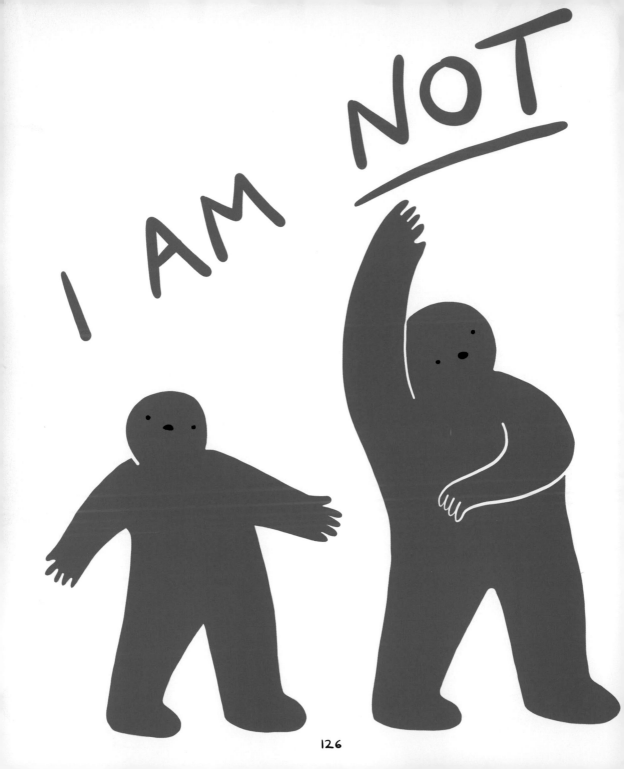

127

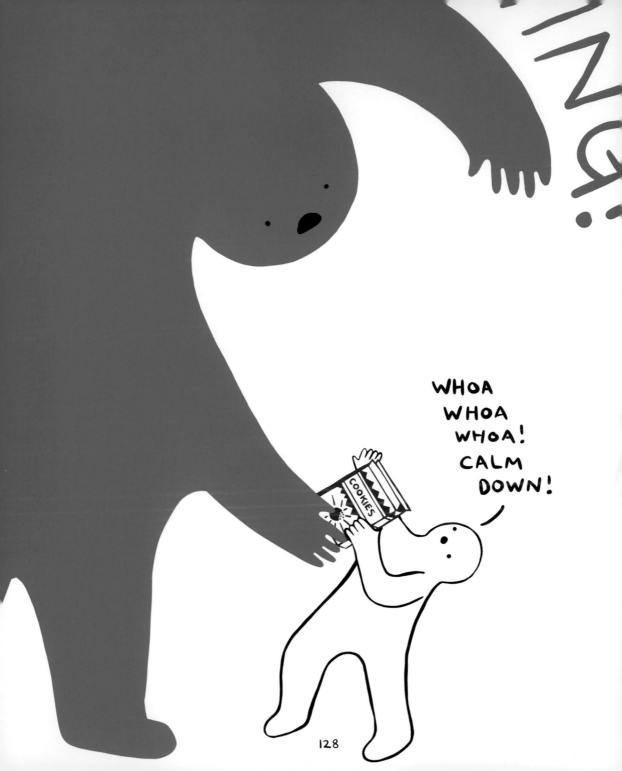

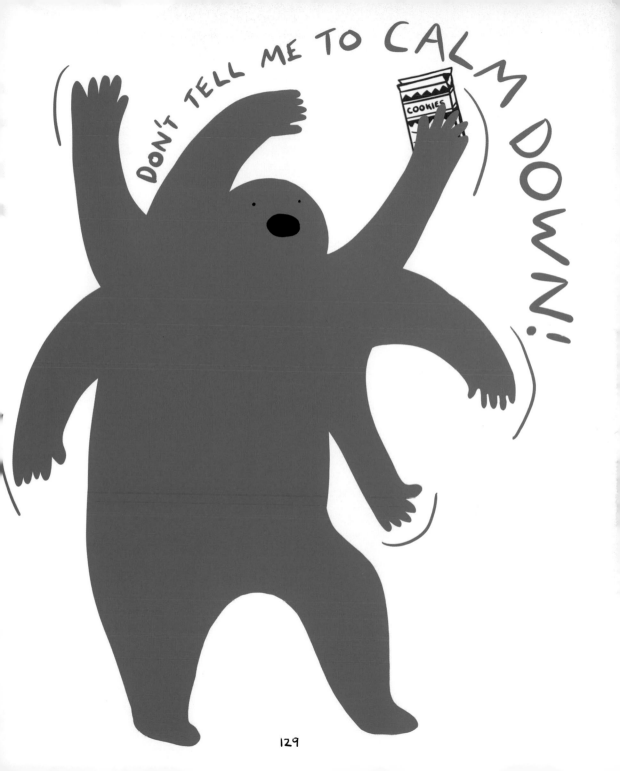

129

COOKIES

131

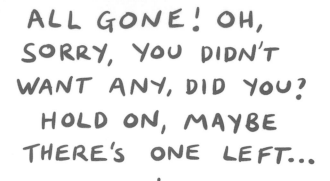

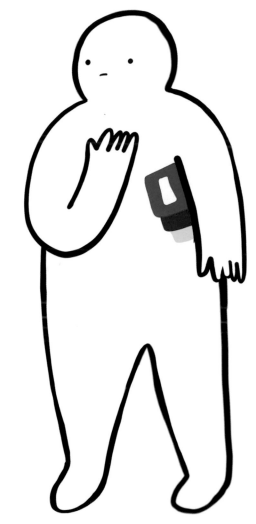

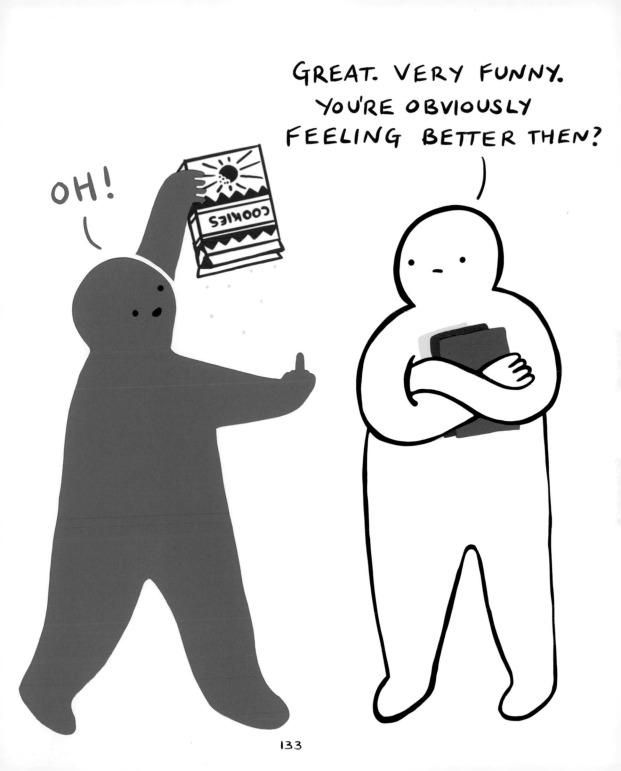

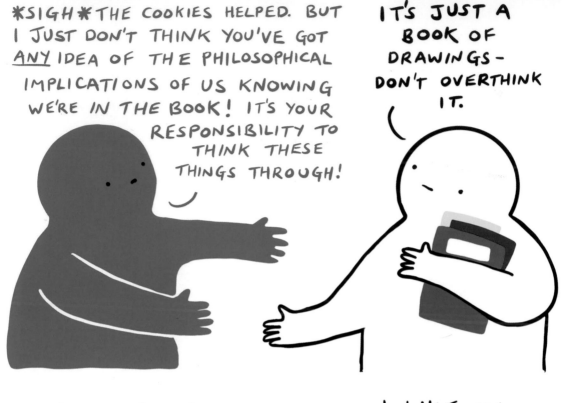

NOTE TO SELF.

SOME DAYS ARE

BETTER THAN OTHERS

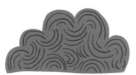 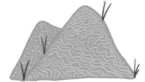 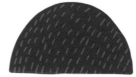

DAILY REMINDER.

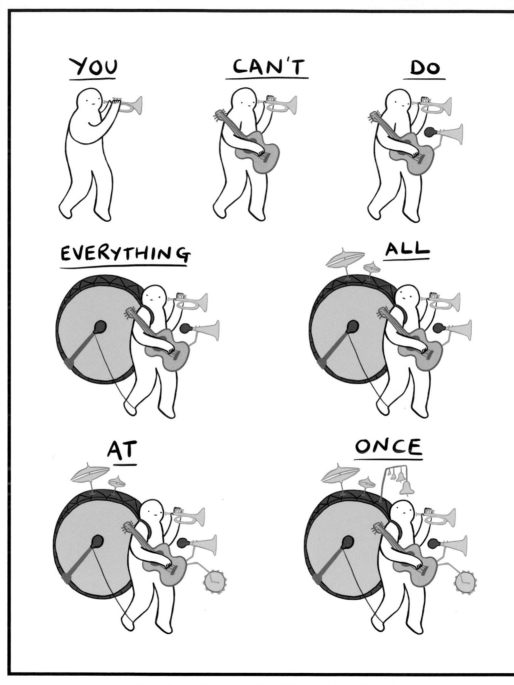

MULTI-INSTRUMENTAL HEALTH MATTERS.

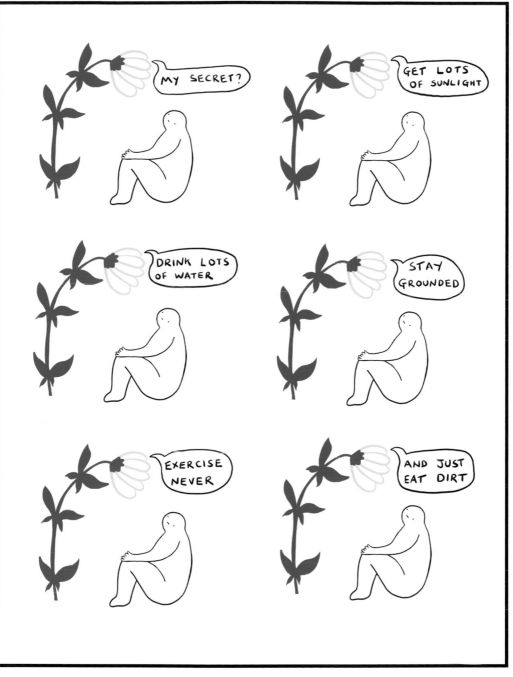

COMMUNING WITH NATURE.

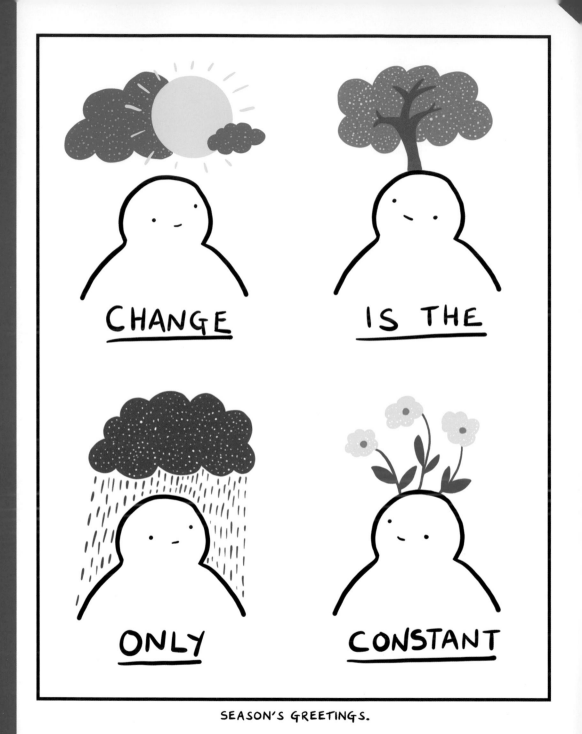

SEASON'S GREETINGS.

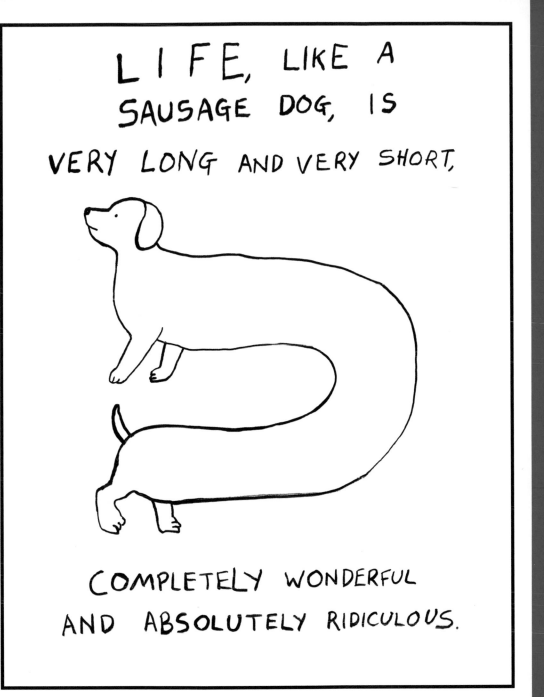

LIFE, LIKE A SAUSAGE DOG, IS VERY LONG AND VERY SHORT, COMPLETELY WONDERFUL AND ABSOLUTELY RIDICULOUS.

AND FULL OF BACK PAIN.

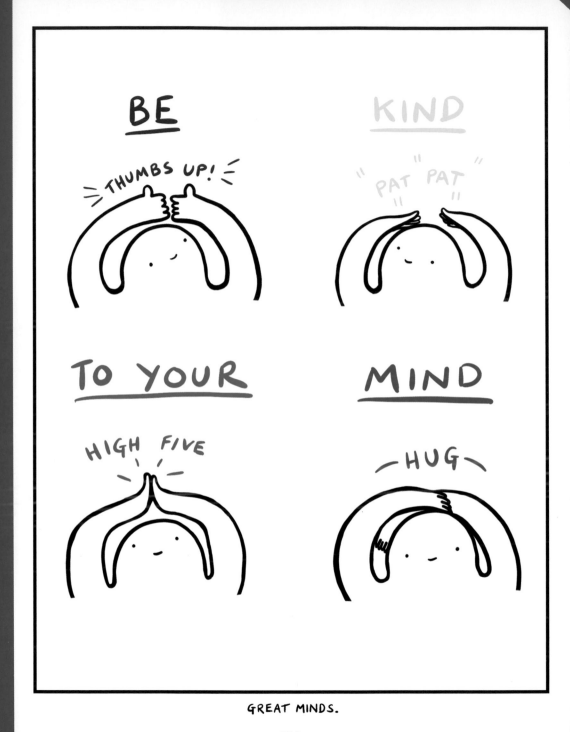

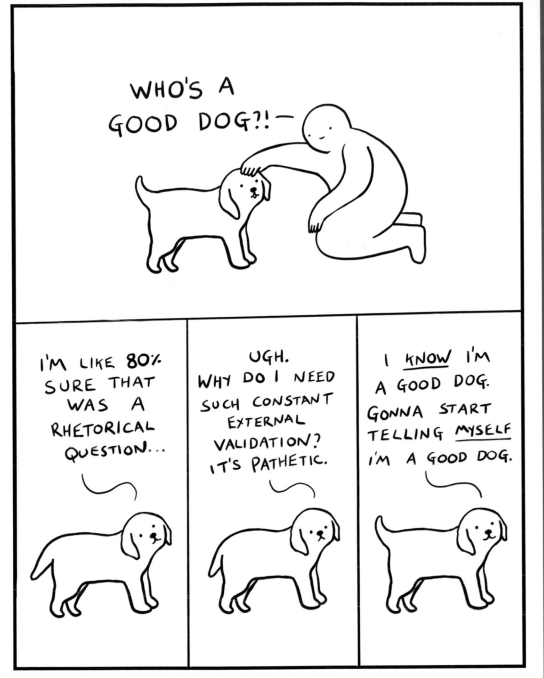

TIME TO GO DIG UP THE GARDEN.

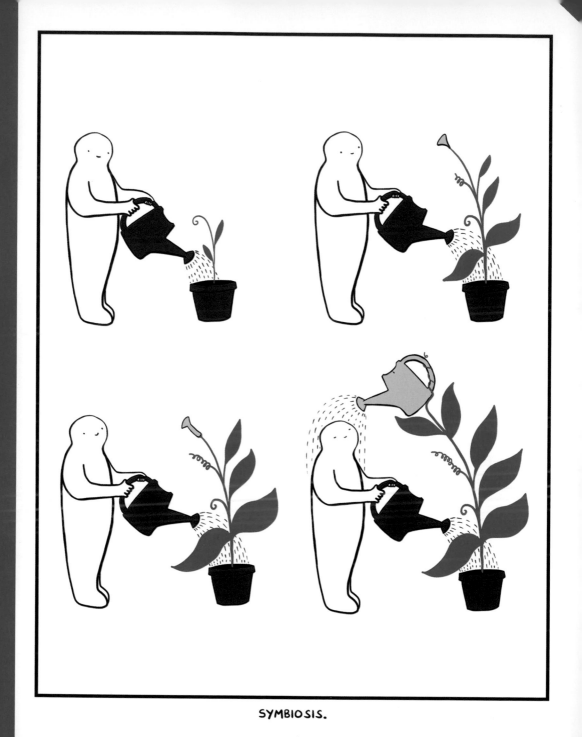

SYMBIOSIS.

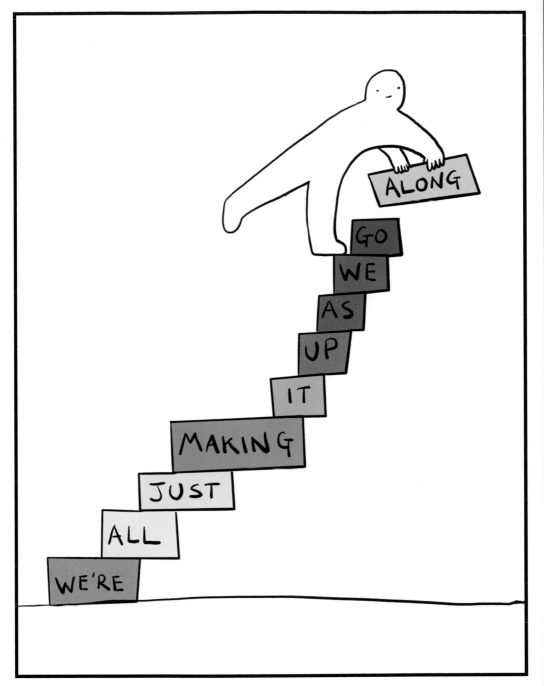

ONWARD AND UPWARD.

149

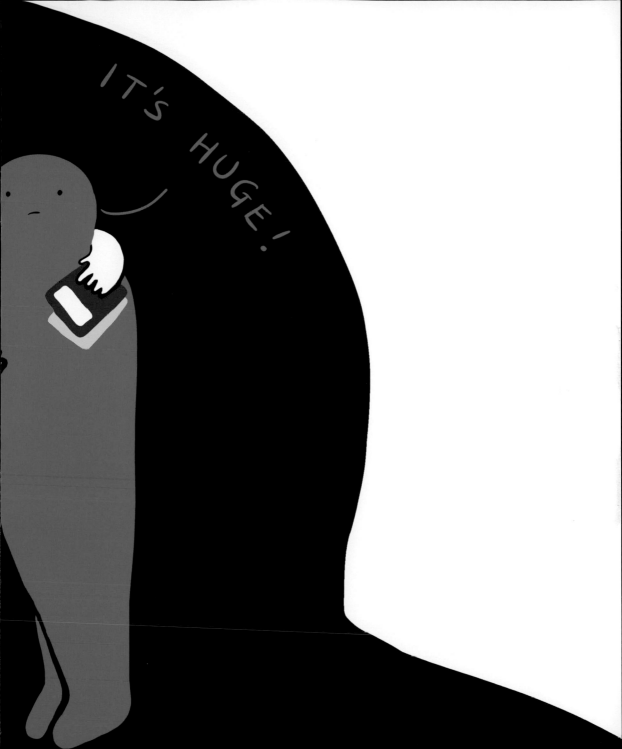

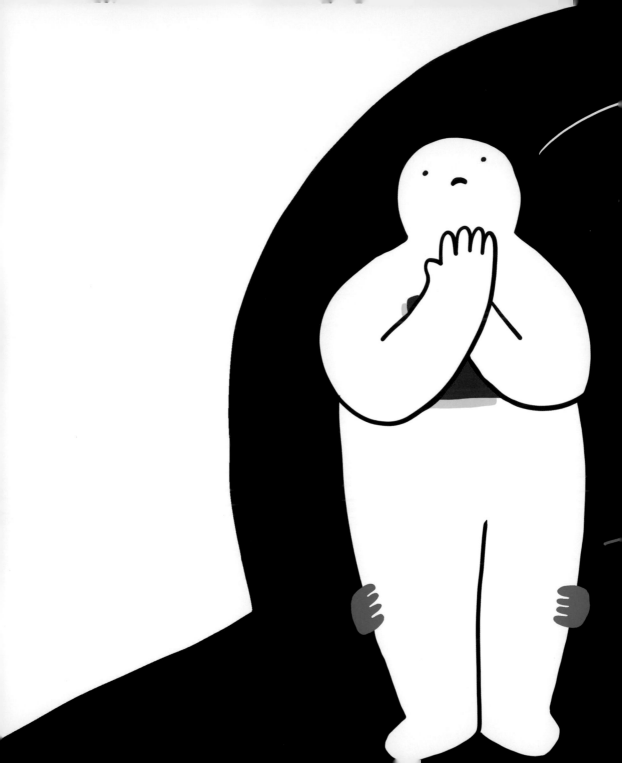

OK.
DON'T
PANIC...
JUST—

WHIMPER?
PASS OUT?

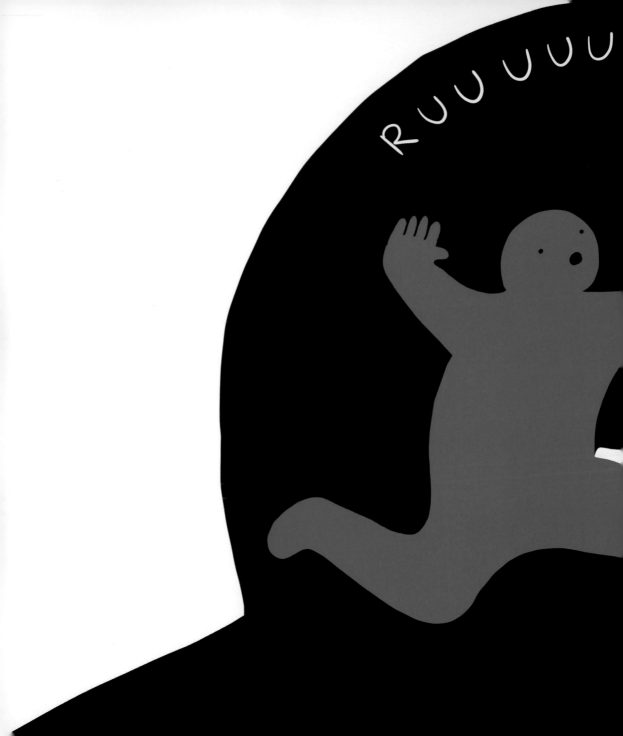

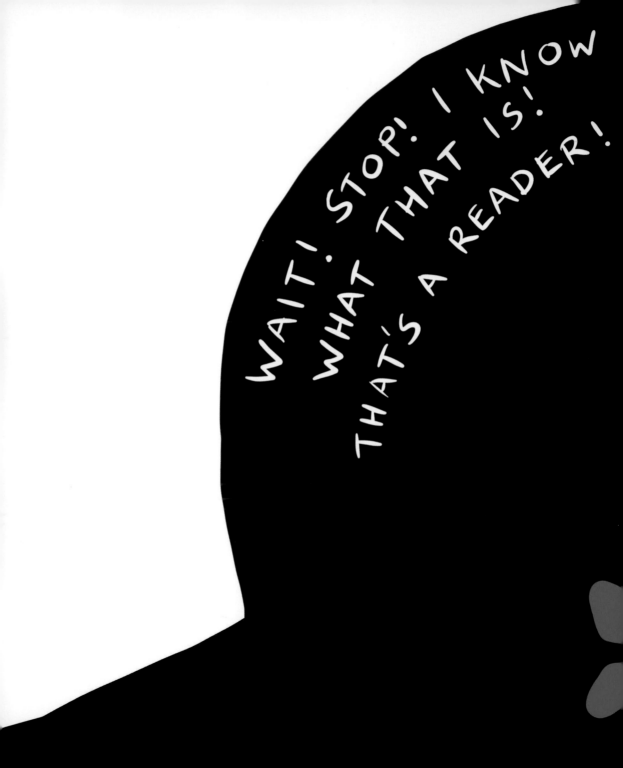

I THOUGHT THEY WERE ALL EXTINCT!

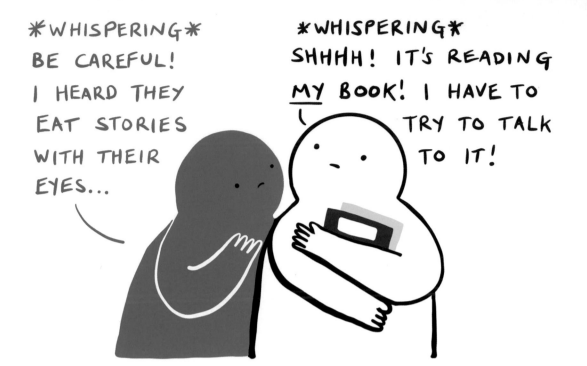

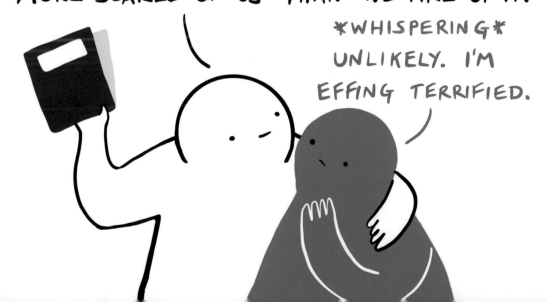

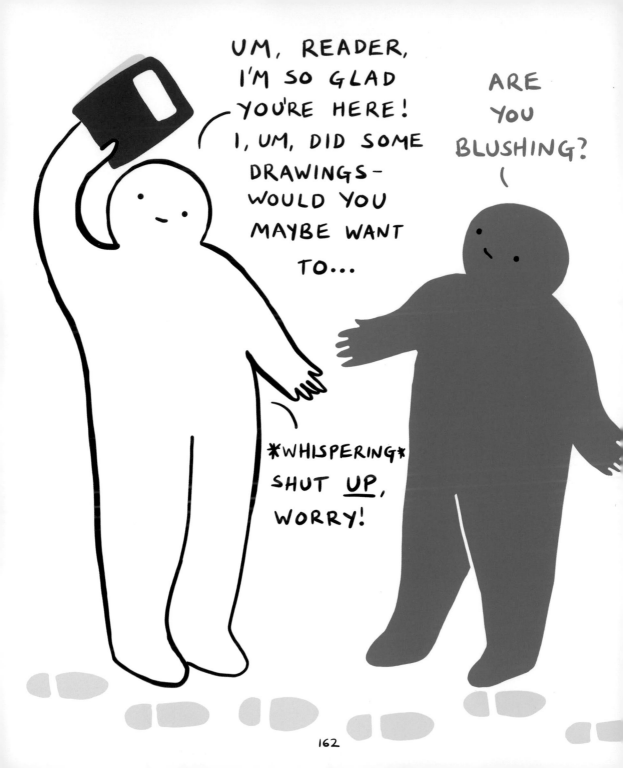

162

DRAWINGS ABOUT
LOVE

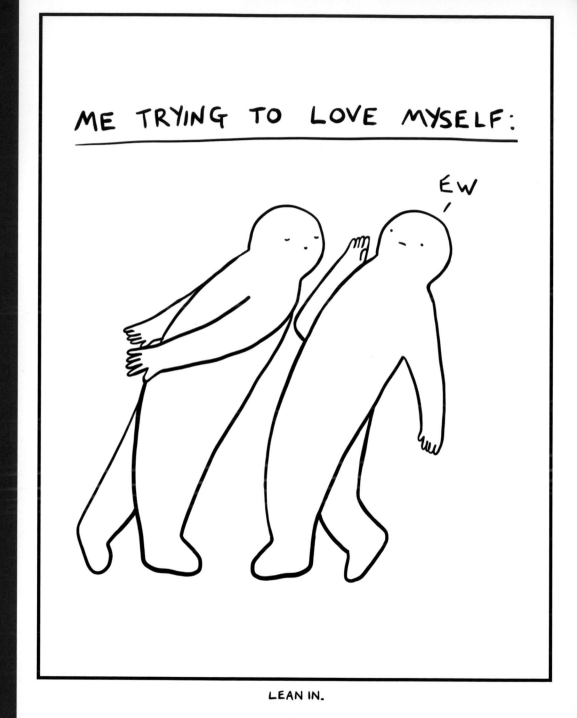

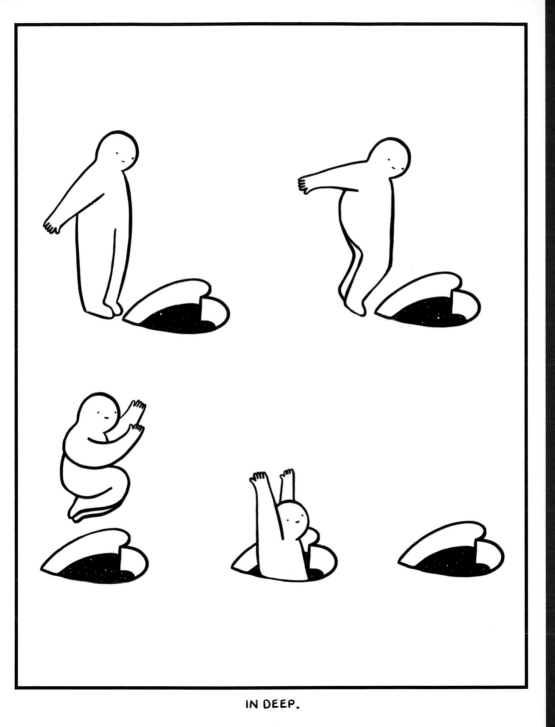

IN DEEP.

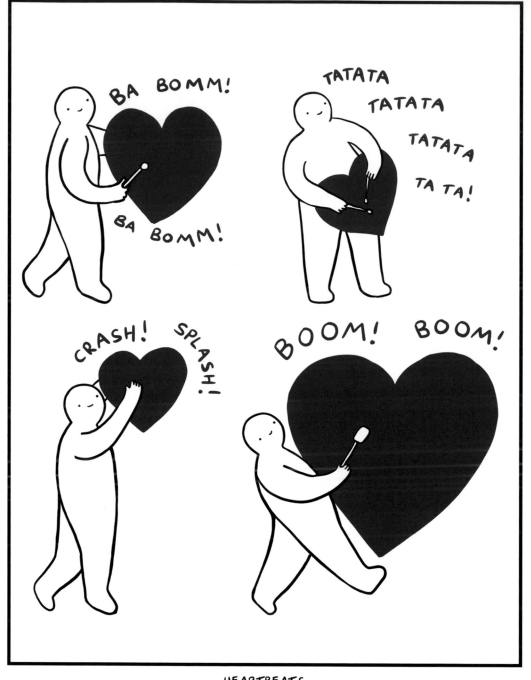

HEARTBEATS.

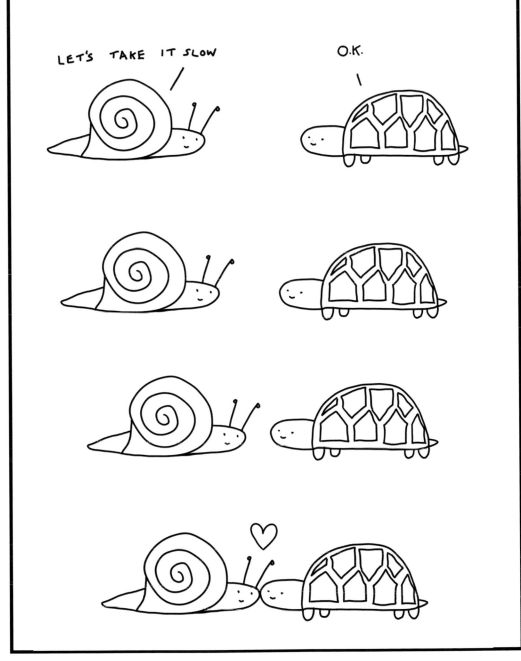

SNAIL'S PACE.

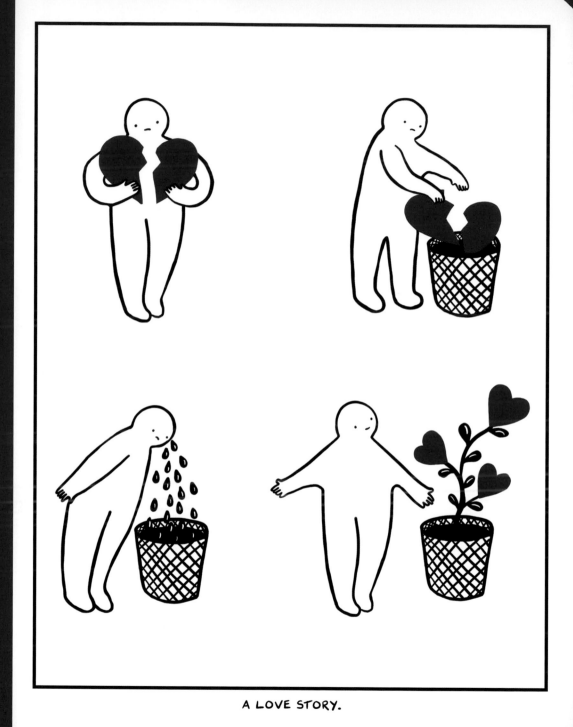

A LOVE STORY.

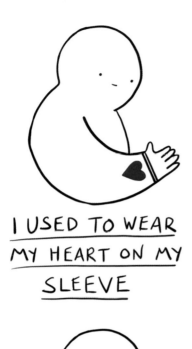

I USED TO WEAR
MY HEART ON MY
SLEEVE

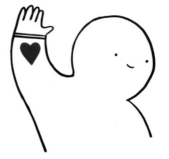

WHERE EVERYONE
COULD SEE IT

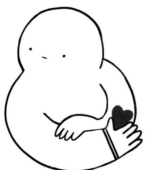

BUT THEN I
CHOSE TO MOVE IT

AFTER SOMEONE
TRIED TO STEAL IT

ALSO, I KEPT ACCIDENTALLY DIPPING IT IN SOUP.

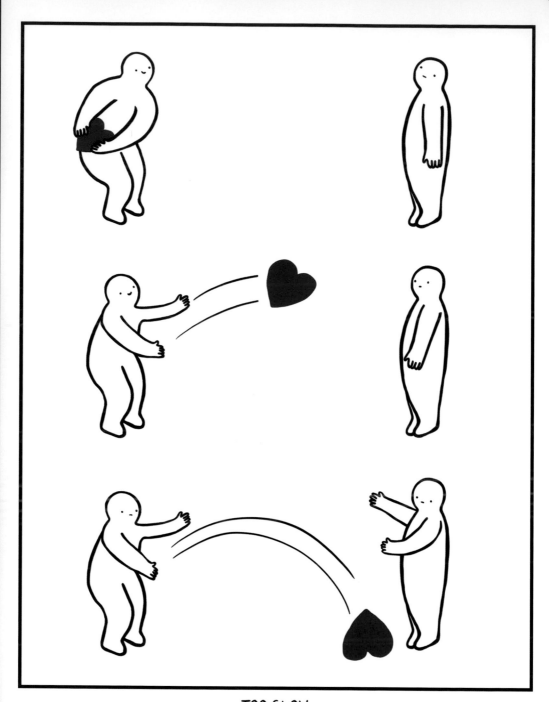

TOO SLOW.

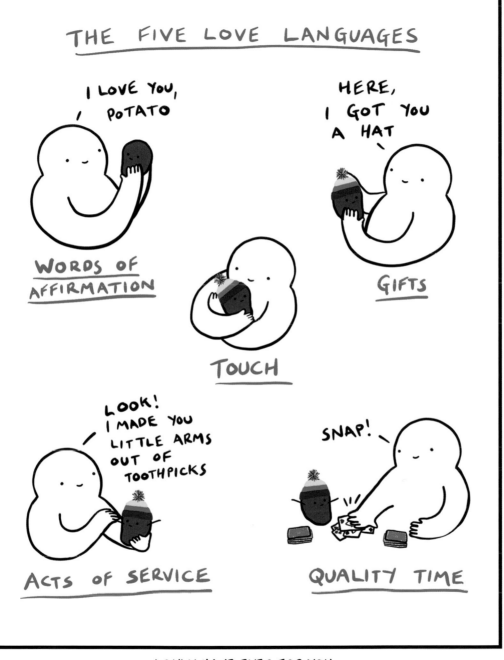

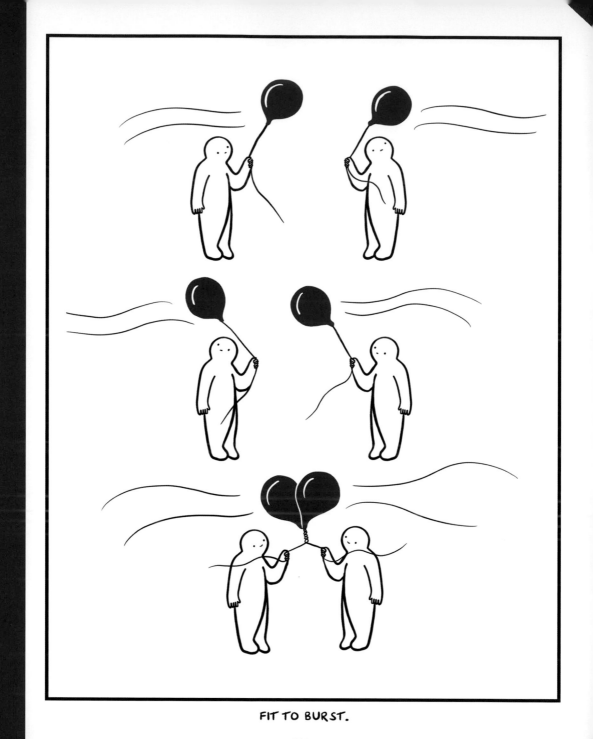

FIT TO BURST.

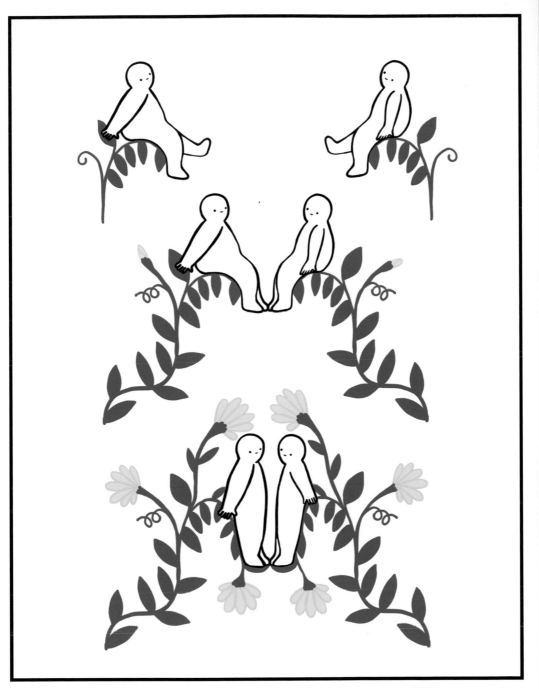

GROW CLOSE.

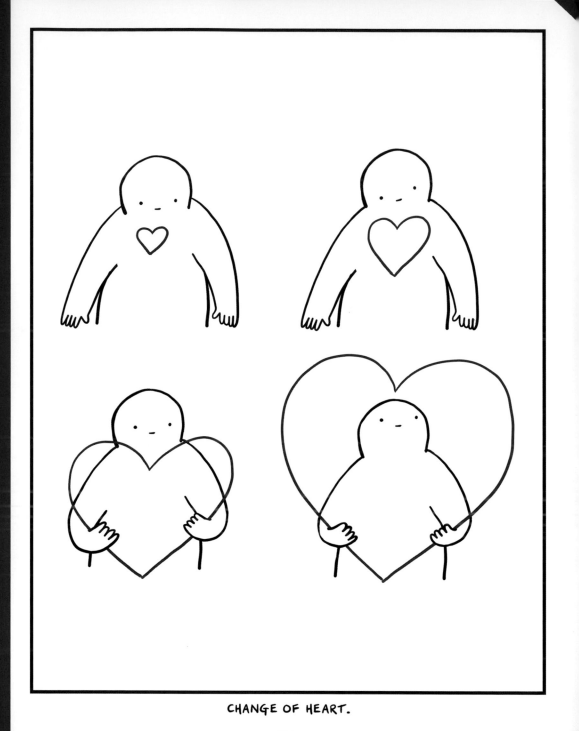

CHANGE OF HEART.

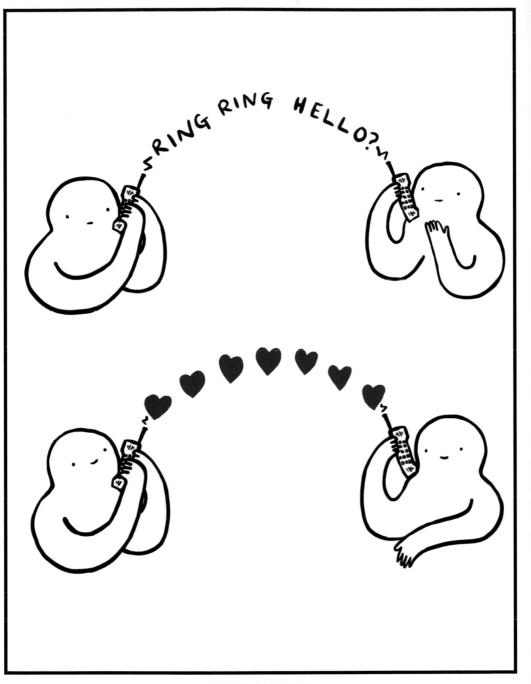

PHONE A FRIEND.

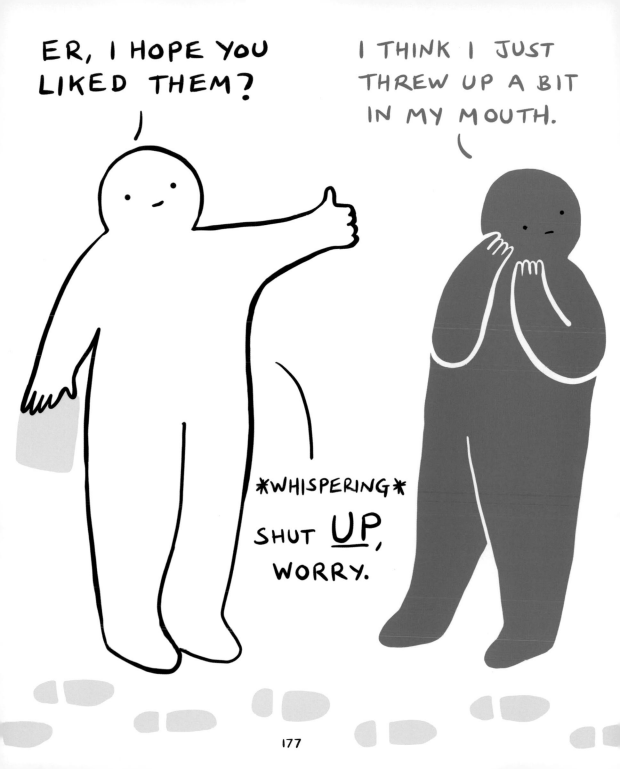

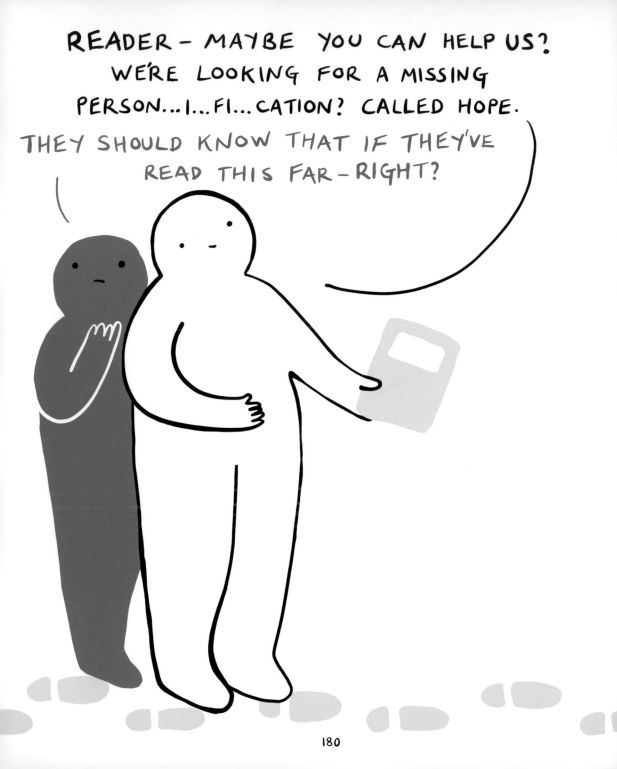

DRAWINGS ABOUT
HOPE

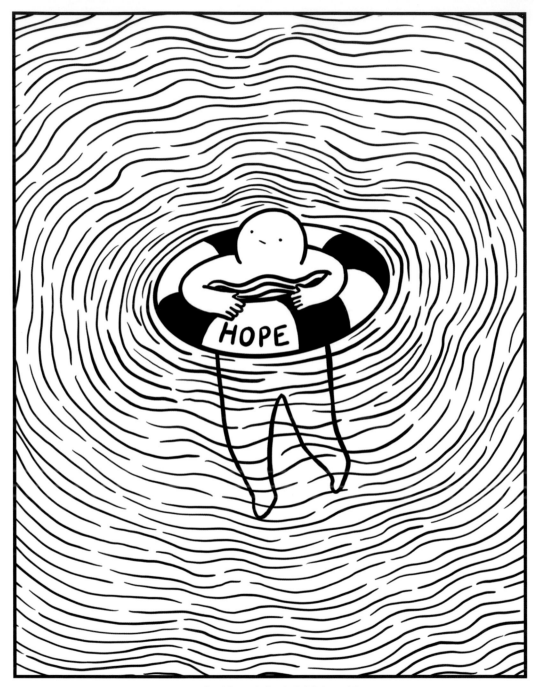

HOLDING ON FOR DEAR LIFE.

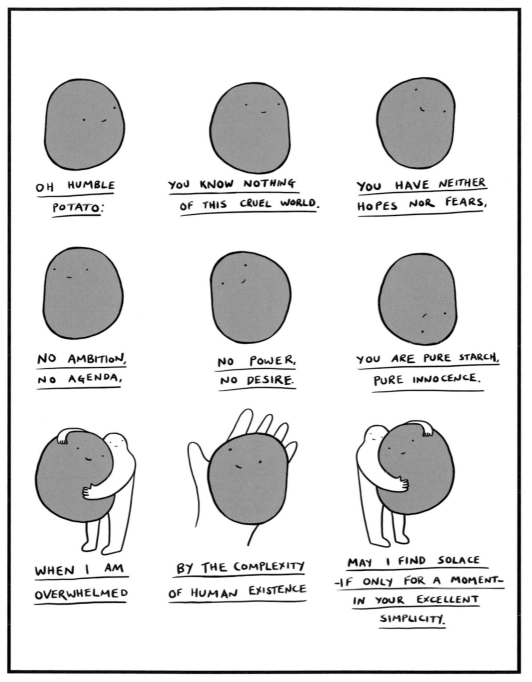

OH HUMBLE POTATO:

YOU KNOW NOTHING OF THIS CRUEL WORLD.

YOU HAVE NEITHER HOPES NOR FEARS,

NO AMBITION, NO AGENDA,

NO POWER, NO DESIRE.

YOU ARE PURE STARCH, PURE INNOCENCE.

WHEN I AM OVERWHELMED

BY THE COMPLEXITY OF HUMAN EXISTENCE

MAY I FIND SOLACE -IF ONLY FOR A MOMENT- IN YOUR EXCELLENT SIMPLICITY.

SWEET POTATO.

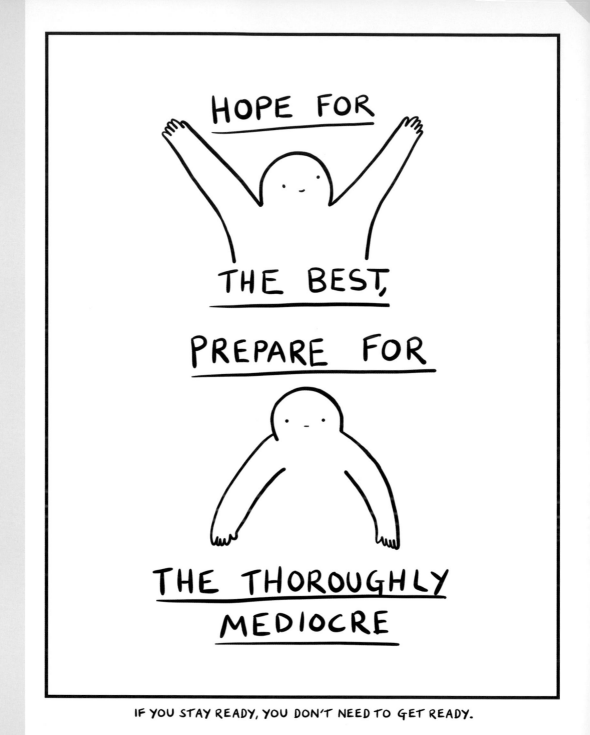

IF YOU STAY READY, YOU DON'T NEED TO GET READY.

KABLOOM.

AFFIRMATIONS

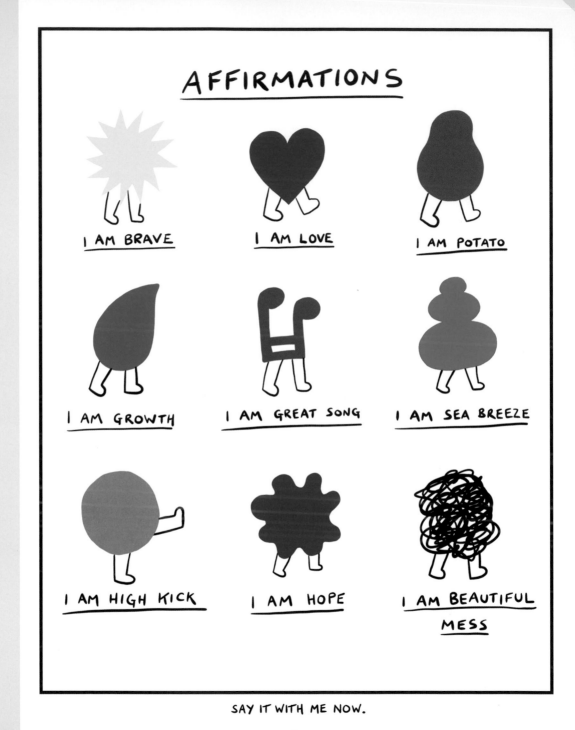

I AM BRAVE

I AM LOVE

I AM POTATO

I AM GROWTH

I AM GREAT SONG

I AM SEA BREEZE

I AM HIGH KICK

I AM HOPE

I AM BEAUTIFUL
MESS

SAY IT WITH ME NOW.

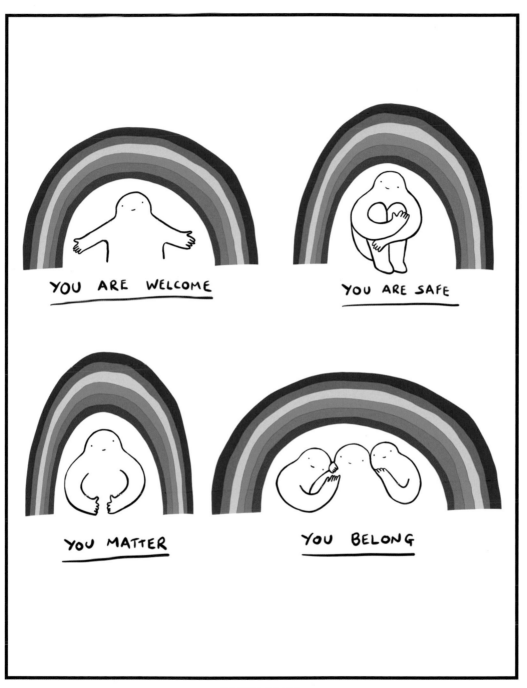

HAPPY PRIDE.

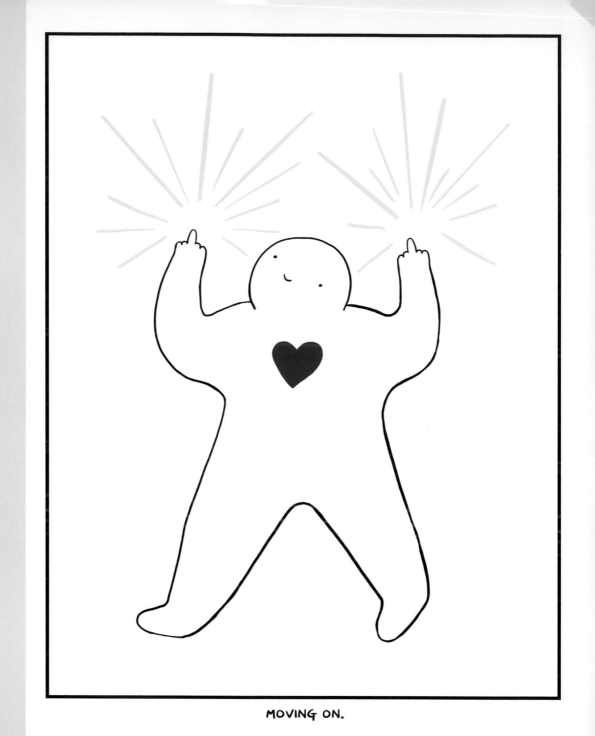

MOVING ON.

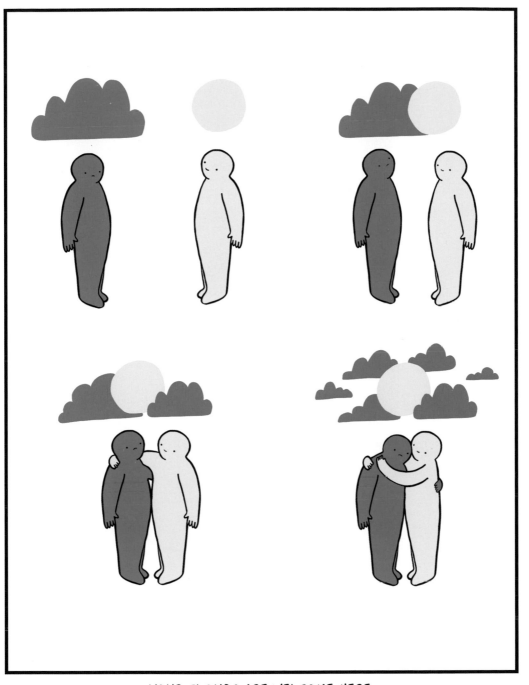

YOUR CLOUDS ARE WELCOME HERE.

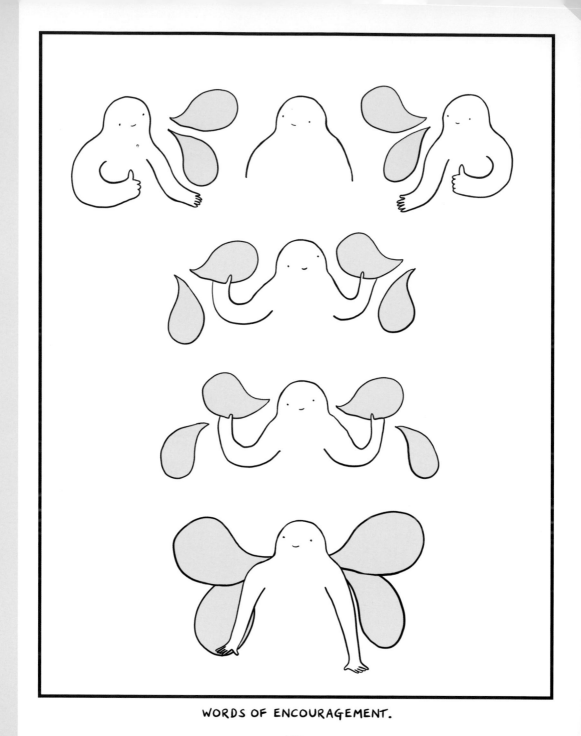

WORDS OF ENCOURAGEMENT.

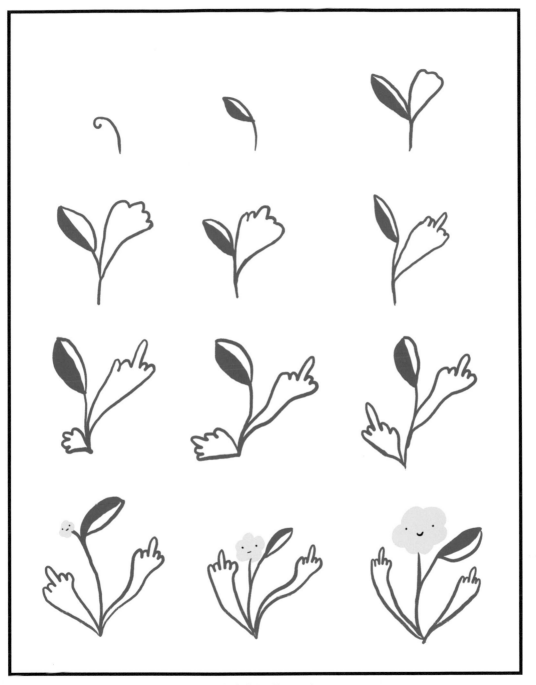

IN FULL BLOOM.

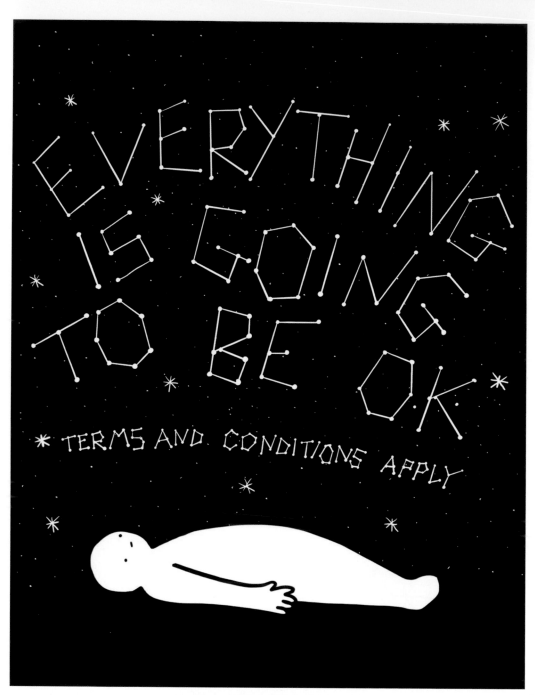

ALWAYS READ THE FINE PRINT.

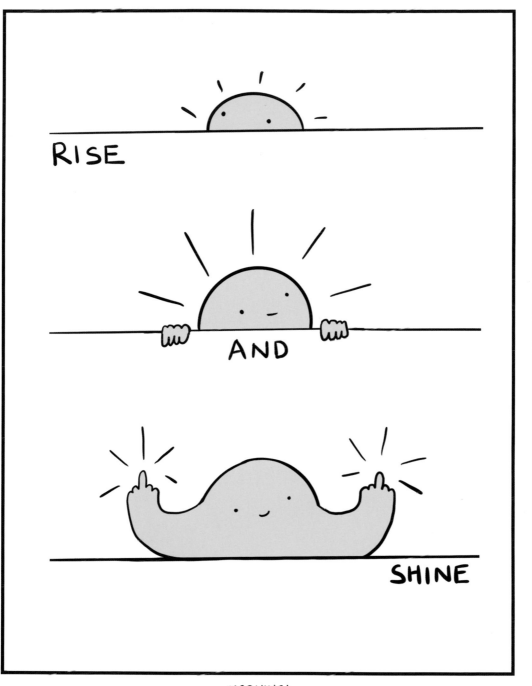

RISE

AND

SHINE

MORNING!

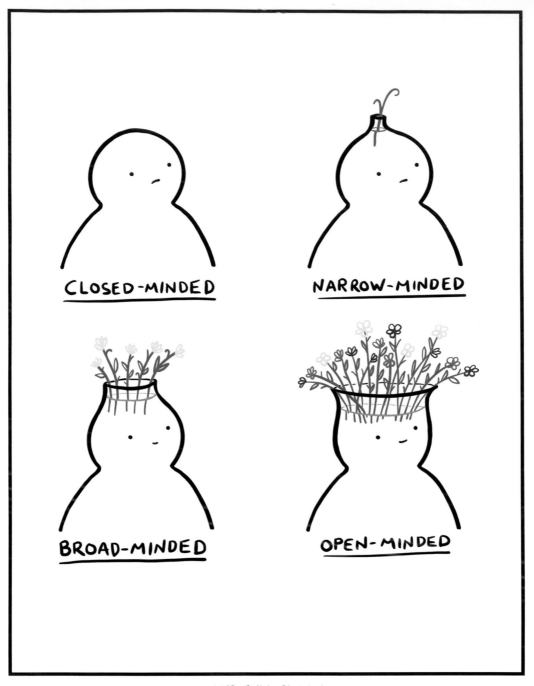

MIND FULL BLOOM.

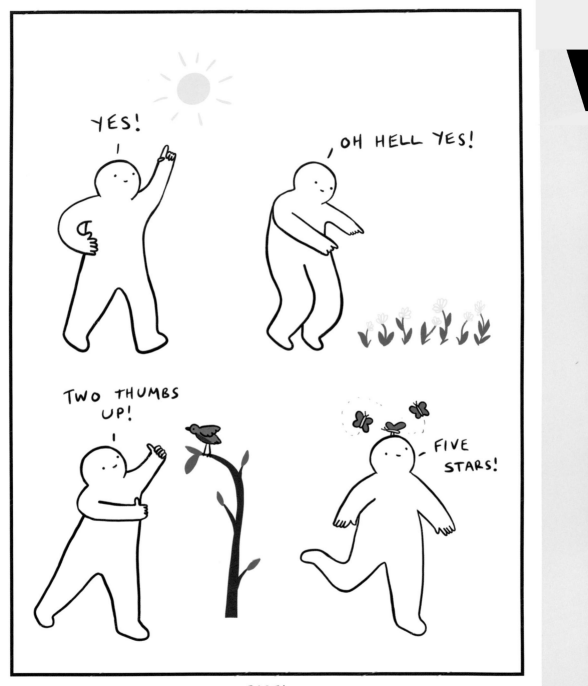

EARTH.

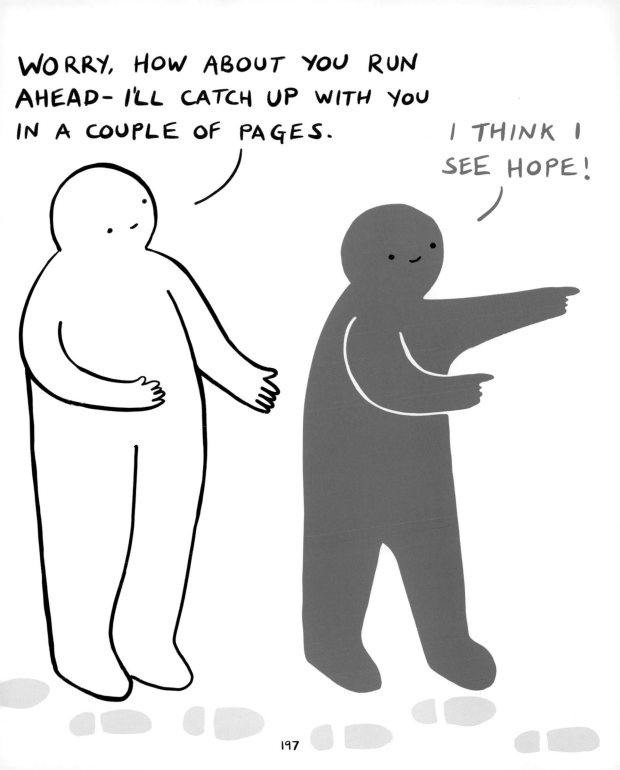

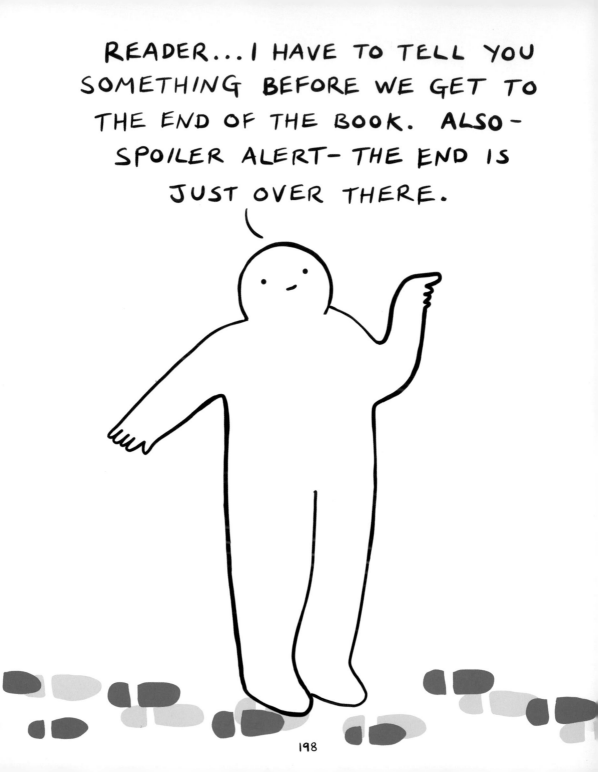

OOF. IT FEELS WEIRDLY VULNERABLE
TO TALK DIRECTLY TO YOU LIKE THIS, BUT
I NEED YOU TO KNOW THAT I AM HONESTLY,
GENUINELY SO GLAD YOU'RE HERE,
READING THIS BOOK.
AND WHEN I THINK ABOUT YOU, WELL...

201

I HOPE THAT ME TALKING ABOUT
MY WORRY MIGHT MAKE IT EASIER
FOR YOU TO TALK ABOUT YOURS.
I MEAN - IF YOU WANT TO.

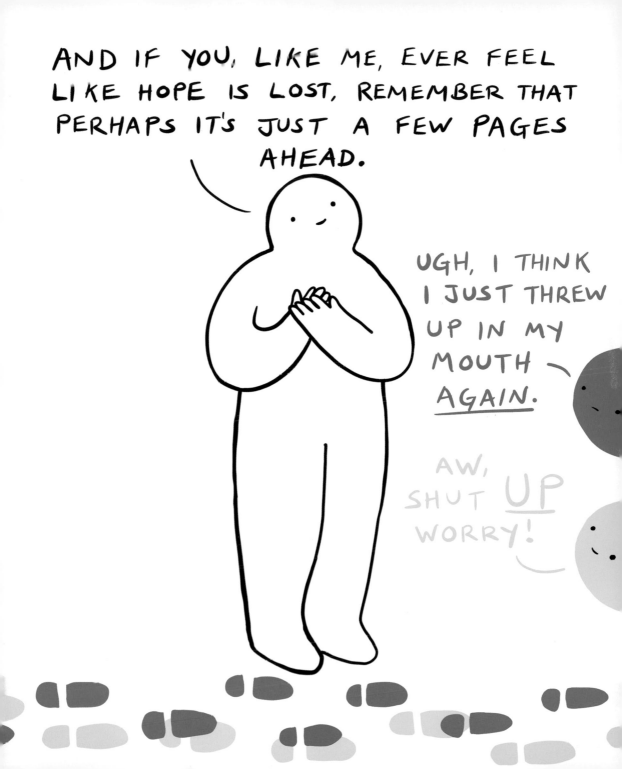

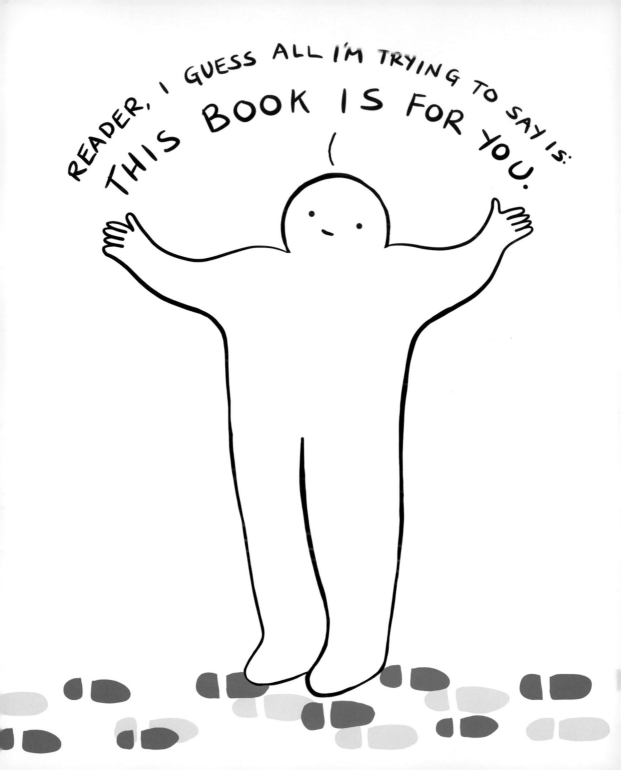

PUBLISHED IN THE UNITED STATES BY
TEN SPEED PRESS, AN IMPRINT OF
RANDOM HOUSE, A DIVISION OF PENGUIN
RANDOM HOUSE LLC, NEW YORK.
WWW.TENSPEED.COM

TEN SPEED PRESS AND THE TEN SPEED PRESS
COLOPHON ARE REGISTERED TRADEMARKS
OF PENGUIN RANDOM HOUSE LLC.

SOME OF THE ILLUSTRATIONS IN THIS
WORK WERE ORIGINALLY PUBLISHED
ON THE AUTHOR'S INSTAGRAM PAGE.

LIBRARY OF CONGRESS CONTROL NUMBER:
2021932480

HARDCOVER ISBN: 978-1-9848-6026-2
EBOOK ISBN: 978-1-9848-6027-9

PRINTED IN CHINA

EDITOR: SARAH MALARKEY
PRODUCTION EDITOR: KIMMY TEJASINDHU
DESIGNER/ART DIRECTOR: CHLOE RAWLINS
PRODUCTION MANAGER: DAN MYERS
COPYEDITOR: CAROL BURRELL
PROOFREADER: KAREN LEVY
PUBLICIST: LAUREN KRETZSCHMAR
MARKETERS: DANIEL WIKEY, MONICA STANTON
AUTHOR'S AGENT: KATE WOODROW

10 9 8 7 6 5 4 3 2 1

FIRST EDITION

THAT'S
THE
END!

FINALLY!
HOW DO WE
GET OUT OF
HERE?

FOLLOW WORRY LINES
ON INSTAGRAM:
@WORRY__LINES